W9-AHA-759

BRIGHT & BEAUTIFUL FLOWERS IN WATERCOLOR

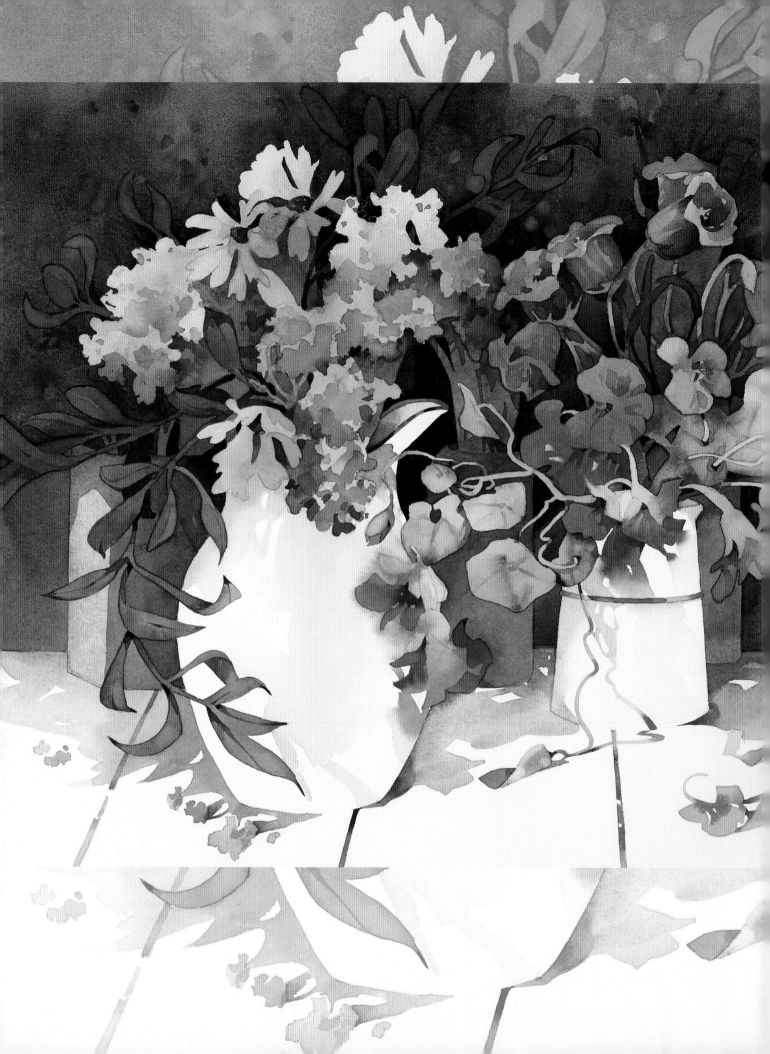

Bright & Beautiful
Flowers
IN WATERCOLOR

Jean Uhl Spicer

NORTH LIGHT BOOKS
CINCINNATI, OHIO
www.artistsnetwork.com

About the Author

Jean Uhl Spicer studied at the Philadelphia Museum School of Art (now the University of the Arts) and received her diploma in illustration. Designing greeting cards was her first commercial venture. She renewed her passion for painting by studying with noted professional instructors, which eventually inspired her to begin a career in teaching. She held classes at local art centers and then moved on to teach painting workshops exclusively. Her national workshops include many northern and southern states on the East Coast.

Jean has earned seven national signature memberships, including full signature membership in the American Watercolor Society and the National Watercolor Society. Her work has been exhibited in many national competitions, including AWS and NWS, and she has served as a juror for many of these competitions. She is the recipient of many prestigious awards, among them two Edgar A. Whitney Memorial awards from the AWS annual exhibit and five gold medals in national competitions.

Jean has appeared in *American Artist* ("Watercolor 94") and *International Artist* magazines and has contributed to the following books: *Watercolor for the Serious Beginner* (Watson-Guptill, 1997), *Splash 5* (North Light Books, 1998), *The Best of Flower Painting* (North Light Books, 1997) and *The Watercolor Landscape: Techniques of 23 International Artists* (International Artist, 2003).

Jean is married to noted illustrator, painter and sculptor Ronald Spicer. They have two sons: Scott, a model maker and sculptor, and Jeffery, an educator and classical musician.

Art from pages 2-3:

TABLE SCENTS
17" × 25" (43cm × 64cm) • *collection of Ms. Taeko Yonetani*

Bright & Beautiful Flowers in Watercolor. Copyright © 2004 by Jean Uhl Spicer. Manufactured in China. All rights reserved. No part of this book may be reproduced in any form or by any electronic or mechanical means including information storage and retrieval systems without permission in writing from the publisher, except by a reviewer who may quote brief passages in a review. Published by North Light Books, an imprint of F+W Publications, Inc., 4700 East Galbraith Road, Cincinnati, Ohio 45236. (800) 289-0963. First edition.

Other fine North Light Books are available from your local bookstore, art supply store or direct from the publisher.

08 07 06 05 04 5 4 3 2 1

Library of Congress Cataloging in Publication Data
Spicer, Jean Uhl.
 Bright & beautiful flowers in watercolor / Jean Uhl Spicer.— 1st ed.
 p. cm
 Includes index.
 ISBN 1-58180-408-3 (hc. : alk. paper)
 1. Flowers in art. 2. Watercolor painting—Technique. I. Title.

ND2300.S665 2004
751.42'24343—dc22 2003070157

Editor: Stefanie Laufersweiler
Designer: Wendy Dunning
Production artist: Lisa Holstein
Production coordinator: Mark Griffin

METRIC CONVERSION CHART

To convert	to	multiply by
Inches	Centimeters	2.54
Centimeters	Inches	0.4
Feet	Centimeters	30.5
Centimeters	Feet	0.03
Yards	Meters	0.9
Meters	Yards	1.1
Sq. Inches	Sq. Centimeters	6.45
Sq. Centimeters	Sq. Inches	0.16
Sq. Feet	Sq. Meters	0.09
Sq. Meters	Sq. Feet	10.8
Sq. Yards	Sq. Meters	0.8
Sq. Meters	Sq. Yards	1.2
Pounds	Kilograms	0.45
Kilograms	Pounds	2.2
Ounces	Grams	28.6
Grams	Ounces	0.035

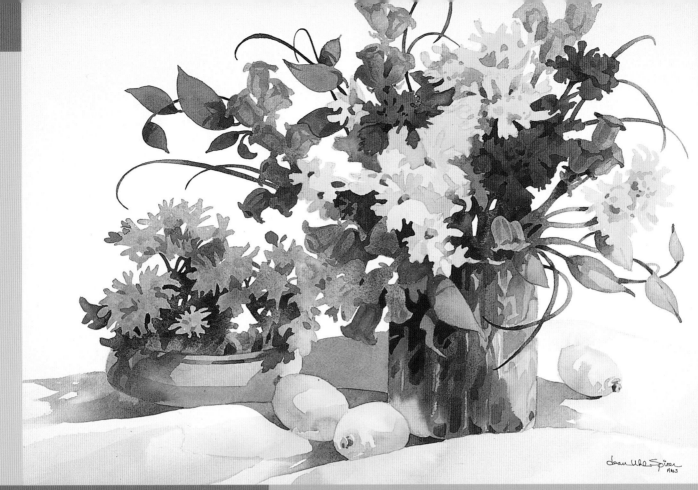

GIFTS FROM THE GARDEN
15" × 22" (38cm × 56cm)

Dedication

To Ron—my lifelong partner who shares my love of art and life—the most talented and gifted artist I know.

Acknowledgments

I want to thank my husband, Ron, for being there when I needed his advice and support. His understanding of the many hours I spent in the studio was so appreciated, as well as his help with camera shots.

Many thanks go to my loving family. To our sons, Scott and Jeff, and their wives, Joann and Cynthia, who are all whiz kids with computers. When I was strapped for time, they were there to help with the text and to make sure that the computer behaved itself.

The photography in this book was accomplished with the expert assistance of Robert Coldwell, a professional photographer who resides in West Chester, Pennsylvania. Through trial and error he helped me to produce the many slides I needed. He can also be credited for the reproduction of the paintings on the title page, the introduction and the chapter openers. Thanks, Bob.

Last but not least, I wish to thank my talented editor, Stefanie Laufersweiler. She was always available to assist and to support me, for which I will be eternally grateful. It was her job to see that my text made sense and to keep me on track. I also wish to thank acquisition editor Rachel Rubin Wolf; without her initial request for me to be an author, this book would not have happened.

Table of Contents

INTRODUCTION

Investigate the best use of rich color to enhance your floral paintings. Explore artistic options for composition, color and design. Get loose and creative within good design boundaries.

8

1

Getting Started

10

Find out the essential painting supplies you'll need to get started.

2

Mixing Clean, Bright Color Every Time

18

The first step to mixing gorgeous color is to understand the properties of your paints. Learn the characteristics of color, then make charts to explore different color combinations. Discover how to mix grays, greens and earth tones that glow. Practice layering color by glazing and working with a limited palette.

3

Developing a Great Composition

Pull an attractive composition together using value sketches, color studies and contour line drawing. Dramatize your work by selecting the best light for your subject. Evaluate reference photos and determine how they can be improved upon for a painting. Learn how to interpret your research and exploit color for the best results.

4

Exercises to Improve Your Art

Explore negative painting, try to paint the background first, unite your design by making color connections, and loosen up by painting without a plan. These exercises and more will stretch your skills as an artist.

5

Painting Flowers Step by Step

Six demonstrations present different floral subjects in a variety of situations. Each painting focuses on a specific challenge: using light and shadow; saving the background for last; creating a vignette; working on hot-pressed paper; handling the elements of a still life, including lace and crystal; and making silk or dried flowers look real and vibrant in your painting.

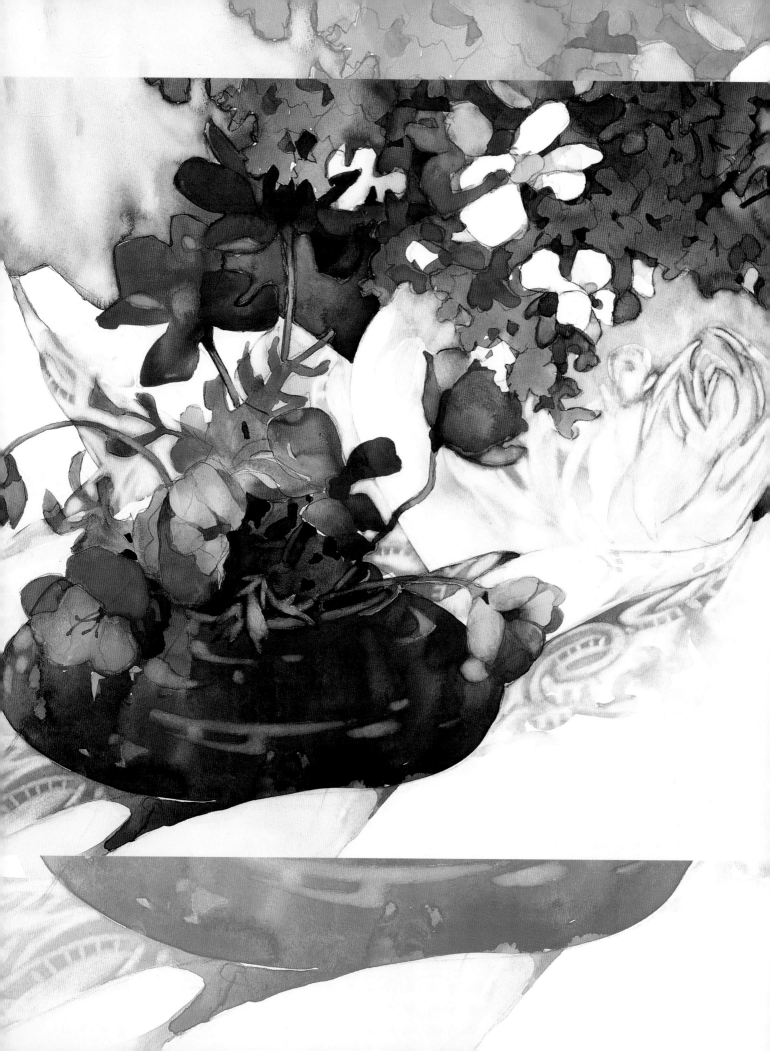

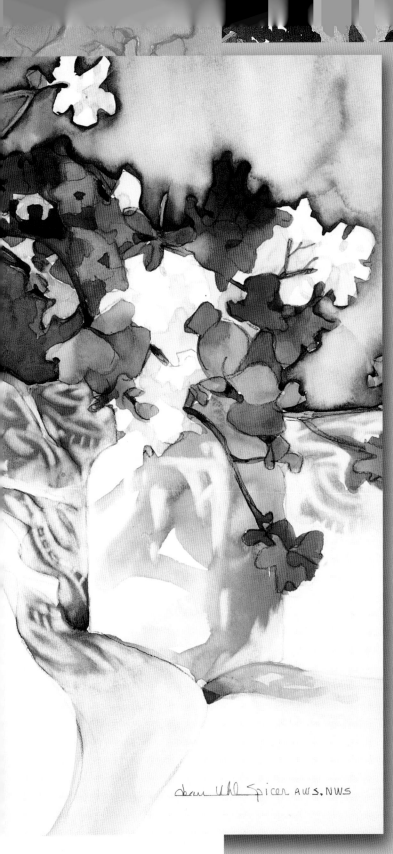

Joan Uhl Spicer AWS, NWS

Introduction

The contents of this book are a result of the years I have dedicated to studying, painting and teaching. I hope to impart to you some of these experiences with easy-to-understand instructions. Wipe the slate clean and rid yourself of any intimidations. Relax, enjoy and, most importantly, have fun using this book as a tool to further your artistic talents.

Make your paintings glow by trying my carefully selected pigments. Transparent colors make up the majority of my palette. You will find out how to work with them by painting the color charts and trying out the mixing recipes provided for you. I will also demonstrate the use of opaques and how they can affect the outcome of your work.

Discover how to put together a good composition, whether you're working from life, reference photos or both. See how to simplify your designs by working with basic shapes even when your subject matter may seem very complicated. Building a satisfying composition can be fun and quite easy to do, as my illustrations will show.

I have also included favorite painting exercises that are popular with my workshop students. Practice negative painting, starting with a background first, pulling a composition together with color connections and painting without a set plan. All of these exercises will loosen you up while sharpening your painting skills.

Perhaps the best way to show you how I work is through the step-by-step demonstrations. Learn my approach of applying good design and brilliant colors for beautiful flowers instead of relying on an overabundance of details.

Above all, I hope you will enjoy the flower-painting experience by lending your own enthusiasm and special talents to the process. With time and practice, you will come up with your own winning combination for painting success.

NATURE'S FASHION SHOW
14" × 22" (36cm × 56cm) • collection of Mr. and Mrs. William Hoffmann

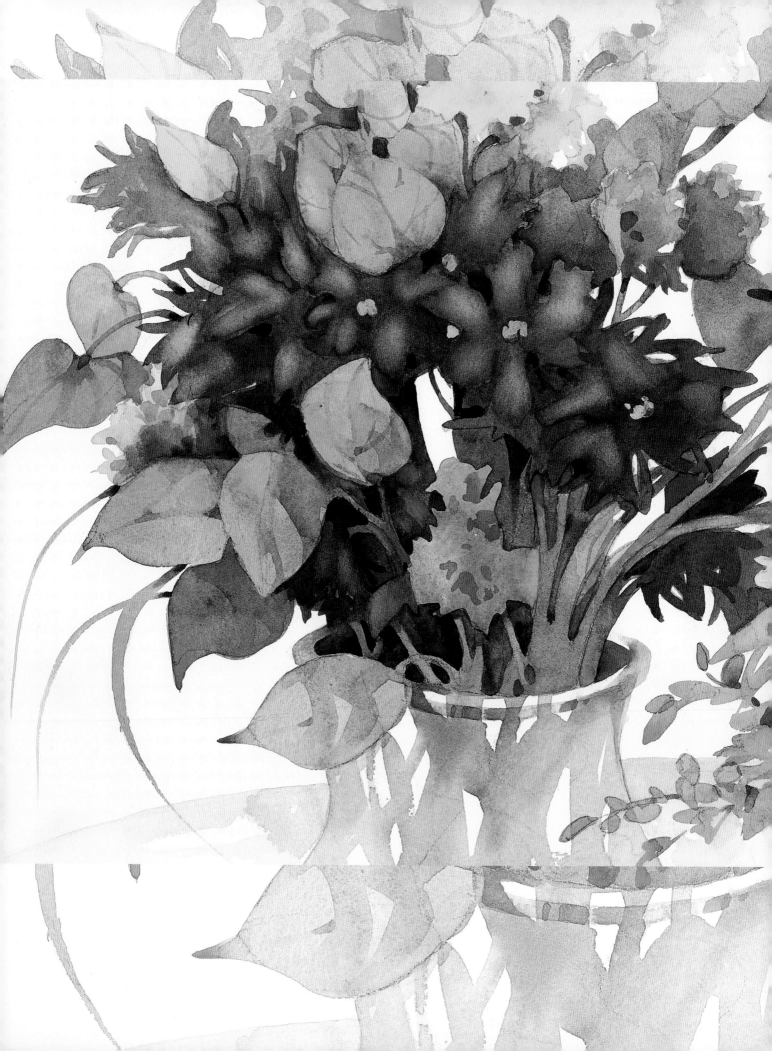

1

Getting Started

Find out the essential painting supplies you'll need to begin your journey to successful painting. The best selections are important if you want good results. Plenty of student supplies are available and economically priced. However, if you want to achieve the best results, choose professional-quality materials.

Discover the exciting, unique results you can achieve by selecting different papers. I'll share with you my must-have brushes and show you what each can do. Your paint options are numerous, but I will simplify this to a palette that includes only the colors you need.

CHERISHED TREASURES
14" × 21" (36cm × 53cm)

Paints and palettes

The watercolors shown on this page are all that you need for beautiful color mixing. A limited palette is less confusing and will add consistency to your work. All pigments are Winsor & Newton's, with the exception of Hansa Yellow by Da Vinci. I also keep Lemon Yellow on hand as a substitute for Hansa Yellow. Try out different brands and colors to see which ones you prefer.

Student-quality pigments are fine for starting out; however, I do suggest that you switch to professional pigments once you feel more confident. Why not get the best results you can?

I use a white metal palette because on it a mixed puddle of color will not bead up (or separate) as it would on a plastic palette, changing the mixture. Also, the metal will not stain. These are available from art stores, art catalogs and photo suppliers. If you like to visit flea markets, as I do, look for old butcher's trays; that's where I found mine.

Palettes and Trays
My main palette measures 12" x 17½" (30cm x 44cm). I use a 5½" x 7½" (14cm x 19cm) palette for mixing individual washes and an 8" x 9" (20cm x 23cm) divided tray, which keeps mixed washes from flowing into each other.

Tip

Always add fresh color to your palette each time you paint. This makes the difference in achieving clean washes that glow.

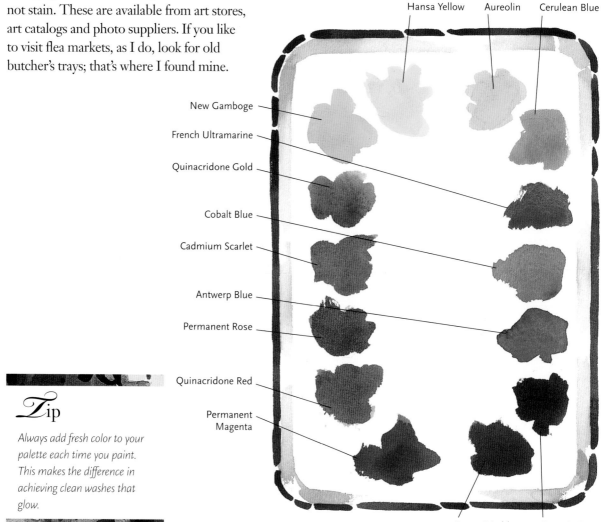

Hansa Yellow Aureolin Cerulean Blue

New Gamboge

French Ultramarine

Quinacridone Gold

Cobalt Blue

Cadmium Scarlet

Antwerp Blue

Permanent Rose

Quinacridone Red

Permanent Magenta

Brown Madder Payne's Gray

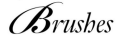

Brushes

What matters isn't necessarily how many brushes you have but the quality and versatility of the ones you choose. Have a variety of different-shaped brushes on hand. Try to pick ones that can perform multiple tasks—for instance, a round that can give you a variety of lines. Discover what each brush can do, so you can choose the best one for the job.

Protect your brushes. Mine are not broken, but they have masking tape around the junction of the wood handle and metal ferrule to prevent water from seeping in and warping the wood, and to prevent the ferrule from rusting and loosening.

My Essential Brushes

Here are my frequent performers. In this book, some of these brushes are used, with additional rounds and flats as needed. Experiment with different brands, kinds and sizes of brushes to discover your own favorites.

A Two-inch (51mm) synthetic Skyflow (Robert Simmons)—for flooding washes over the entire paper or for covering a large area.

B-D One-inch (25mm), ½-inch (12mm) and ¼-inch (6mm) sable/synthetic flats—for straight edges or angular shapes of different sizes.

E-G No. 5 synthetic round, Happy Stroke no. 3 rigger (Cheap Joe's) and no. 8 sable round—perfect for small lines and details.

H-J No. 7, 10 and 14 sable rounds—full-bodied brushes that hold plenty of color and come to a point well.

K-L No. 2 and 4 squirrel rounds—wonderful for applying washes on any hot-pressed paper or board. The brush can be fully loaded and yet maintain its point.

M No. 1 squirrel/sable fine-point round—gives great variety of line from fat to fine,-all in one brush.

Papers

All of these papers work a little differently. Some have textured surfaces, and others are smooth. Try using each one and see what suits you.

Try painting on hot-pressed watercolor boards, which do not require stretching. Their bright whiteness will enhance your colors, and their smoothness makes corrections easy to do. Use a 2B (medium) charcoal pencil instead of a graphite pencil for initial drawings on these boards, since the latter will indent the surface. To better control the flow of your paint, keep these smooth boards flat on your table as you work.

You'll find that some subjects are better for one paper over another. Explore the avenues. Here are my favorite surfaces.

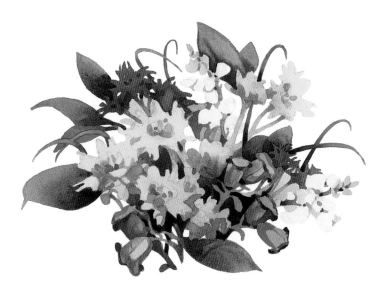

Arches 140-lb. (300gsm) Cold-Pressed Paper
See how the paper absorbs evenly and provides a slight texture. This surface will take the removal of paint quite well when you need to lift out highlights or mistakes. Notice how you can see through all the layers of the transparent washes.

Tip

All papers with weights under 300 pounds (640gsm) should be stretched or they will warp once your painting has dried. To stretch paper, you will need:

- **Gator board ½-inch (12mm) thick.** *Lightweight and good for location or studio work.*

- **Homosote board, ½-inch (12mm) thick.** *You can buy 4' x 8' (122cm x 244cm) panels at a lumberyard and have them cut down to your paper sizes. Good for studio use.*

- **White tape.** *Buy this from an art supply store or catalog. Avoid regular masking tape as color bleeds under the tape and the tape will lift while you're painting.*

- **Stapler**

- **Natural sponge**

- **Tub of water**

Have several boards and papers ready, then follow these steps:

1 *Soak the paper in water for five to ten minutes. The paper will expand.*

2 *Place the paper on your Gator or Homosote board and smooth it out with a damp sponge.*

3 *Apply staples starting at the center of one edge; slightly tug the paper as you go. Place the staples a quarter inch (6mm) in from the edges and about two inches (5cm) apart. Let this dry completely. The paper will contract and lay flat.*

4 *Add the white tape just before you begin painting. This is not to secure the paper but to cover the staples and create clean edges. When your painting is completed, remove the tape and staples.*

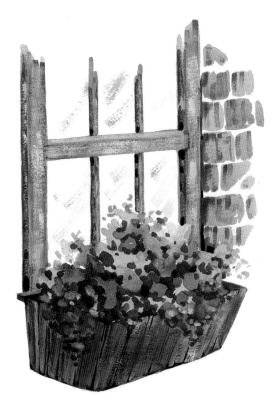

Arches 260-lb. (550gsm) Cold-Pressed Paper
The texture of this paper allows you to describe your subject with scumbling and drybrushing. To scumble, I use an oil brush to drag opaque colors across the top of previously dried transparent colors. Drybrushing involves using paint with very little water added. This surface is ideal for portraying the natural texture of wood, rocks and grasses.

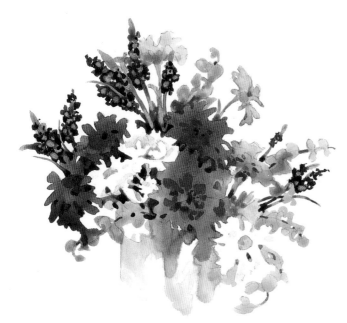

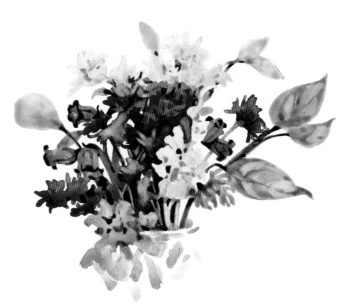

Strathmore 500 Series 4-Ply Plate (Hot-Pressed) Bristol Board

This soft surface has good absorbency even though it is very smooth. This paper receives a gold star for how easily color can be removed from its surface.

Strathmore 500 Series Heavy-Plate (Hot-Pressed) Illustration Board

This board is a timesaver. You can mix and apply washes all at once. The board and paint will do the mixing, resulting in excellent textures. Finalizing a painting involves either adding small dabs of color or removing color, which is easily done on this board.

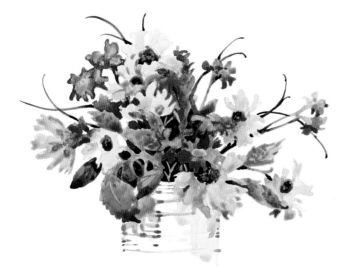

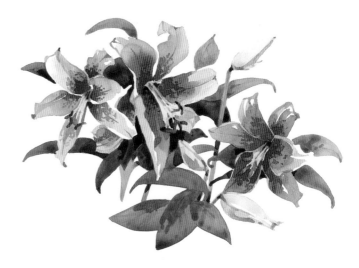

Crescent No. 215 Hot-Pressed Illustration Board, Medium Weight

This is a very slick board. Use fully loaded brushes to drop colors onto the board, and then let the board do the mixing. When it's dry, think like an oil painter and add thicker dabs of color on top for shadows and darks.

Crescent No. 115 Hot-Pressed Watercolor Board

Notice the absorbency, as this surface has a slight texture and is not as slick as the other boards.

Other supplies

Here are some other essentials you will need for painting.

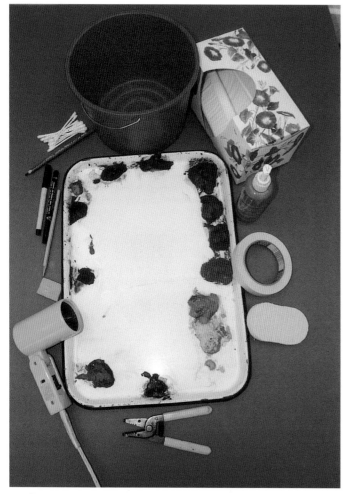

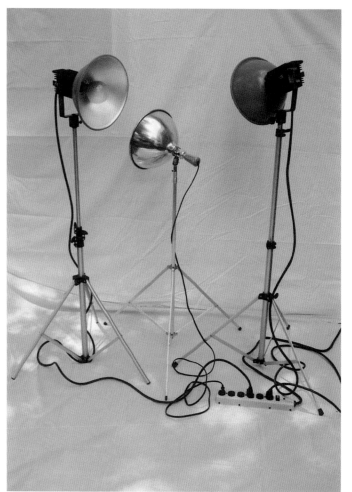

Studio Necessities

My enamel tray palette is invaluable to me. Other basic supplies I have on hand are (clockwise): large water bucket, facial tissues, water-filled spray bottle, masking tape, sponge, wire stripper (for twisting open stuck tube caps), hair dryer, kneaded eraser, HB pencil, fine-point ink pen, Penstix ink drawing pen, 2B charcoal pencil, and cotton swabs (for lifting paint).

Be inventive and try other gadgets such as plastic scrapers, old brushes and salt to create new painting techniques.

Set the Stage With Light

You will need several tripods, reflectors and bulbs so you can try different lighting effects on your subjects. The reflectors should be at least ten inches (25cm) wide to accept standard bulbs of 150 watts. You might also have a 100-watt lightbulb in another reflector to place closer to the subject matter to warm and soften the light. All of this should be plugged into a power strip with a single on/off switch for easy use.

Standard bulbs are incandescent, casting a soft, yellow light. This is used to warm flowers that are yellow, orange or bright in color as well as for adding warmth to green foliage. I sometimes switch to color-corrected bulbs of 100 watts if I want to have a more natural daylight effect. These can be purchased from art catalogs. The bulb glass will be purple in color.

Leaving the studio at home

Why carry bulky materials for location work? Forget the beach chairs and heavy easels. Think light, as you will have to lug everything around. Also, put your supplies on a diet. Instead of twenty-five brushes, take six.

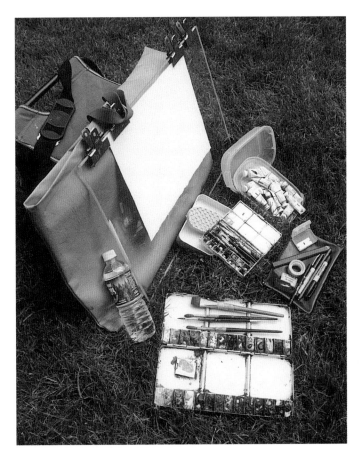

Keep It Simple

My location materials include a vinyl portfolio, a 16" x 23" (41cm x 58cm) Plexiglas support, clips and papers. My seat bag holds everything else: paints, brushes, palette, pencils, pens, sponge and a water bottle.

The 5½" x 12" (14cm x 30cm) folding palette is a favorite of mine for location work. It travels light but is heavy enough to keep it from blowing away in the wind. I fill it with the same colors as my studio palette, and there are plenty of mixing areas and spare areas for seldom used colors. An oval opening for my thumb allows me to hold it easily while working. The smaller palette shown was converted into a paint box by adding small pans of pigment. Retractable brushes fit in it as well. This box is handy for preliminary color sketches.

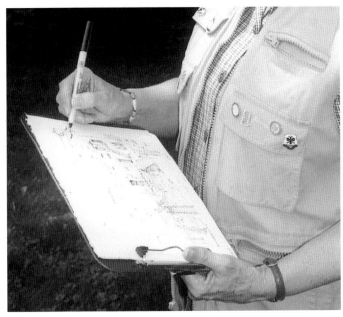

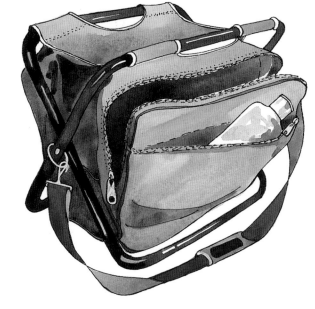

Homemade Sketchbook

Instead of toting around a thick sketchbook, I have made a lighter version by clipping precut quality watercolor papers to a Plexiglas clipboard. I enjoy doing sketches in watercolor and pen and ink, always using professional supplies. Time is valuable, so I consider every sketch important, not a throwaway.

Artist's Seat Bag

The seat bag allows you to tuck yourself into a small area to get that great view. My seat folds flat and fits easily into a suitcase. It is lightweight, waterproof and measures 17⅜" x 9⅝" x 13" (44cm x 24cm x 33cm). When filled with supplies, it can be carried by the shoulder strap. A similar seat bag called the "Pack Stool" is available at Art Supply Warehouse, (800) 995-6778 or www.aswexpress.com. It has the added advantage of a back rest. You might find additional options through other art supply stores and catalogs.

Mixing
Clean, Bright
Color Every Time

One of the most important aspects of painting is color selection. To fully understand how pigments work, you need to investigate their properties. Are they warm or cool? Which are transparent, opaque or semiopaque? Is there sediment in the mix? Knowing this will allow you to make better choices and weed out unnecessary colors. Choosing a palette is like being in a candy store: We want it all but must choose wisely. We all have our favorite colors. You do not have to forsake the ones you love—just get to know them. Completing color charts will help you understand how colors affect one another. We will explore the nuances of mixing greens, grays and earth tones.

Glazing with transparent washes reflects the true beauty of watercolor. This builds values from light to dark and at the same time allows the underlying colors to show through. Opaques have an important job to do as well. They can be mixed with transparent colors or added as final touches. Let's discover what our paints can do!

TEATIME WATCH
14" × 22" (36cm × 56cm)

The basics of color

Before you can get started mixing color, you first need to understand the different properties and characteristics of color. This is essential to mixing the colors you want instead of guessing what will work.

Here are some key color concepts that you should know before you start mixing color:

- **Primary colors**—the colors from which all other colors can be mixed. The primaries are red, yellow and blue.
- **Secondary colors**—the colors created when one primary is combined with another. The secondaries are violet (red plus blue), orange (red plus yellow) and green (yellow plus blue).
- **Tertiary colors**—the colors that result from combining a primary with a secondary. In naming these colors, the primary color used in the combination always precedes the secondary. The secondary colors are red-violet, red-orange, blue-violet, blue-green, yellow-orange and yellow-green.
- **Analogous colors**—colors that appear next to or close to each other on the color wheel (for example, yellow-green and green).
- **Complementary colors**—colors that appear directly across from each other on the color wheel (for example, yellow and violet).
- **Value**—the degree of lightness or darkness of a color.
- **Temperature**—the warmth or coolness of a color. Yellows and oranges are generally considered warm, while blues and violets are generally considered cool. However, temperature is always relative. For example, you might have a blue that is warm compared to another cooler blue.
- **Intensity**—a color's saturation, strength or brightness.

Value Scale

The scale on the left is a standard black-and-white value scale, in which lightness or darkness is measured in increments of one to ten. The scale on the right shows the value range of Cadmium Scarlet.

The Basic Color Wheel

The standard color wheel is comprised of twelve colors arranged in this way. Understanding a color's placement on this wheel will make it easier to apply and mix colors for the results you want.

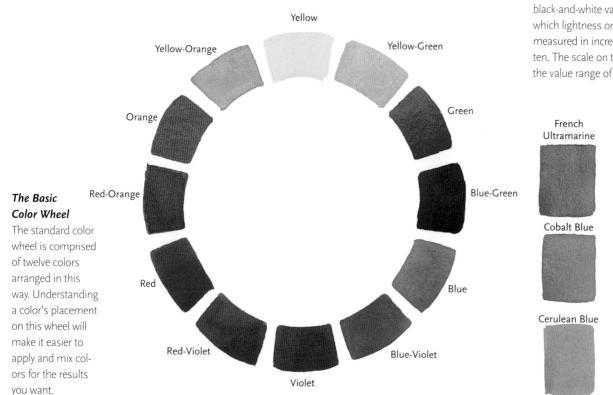

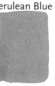

Color Temperature

The temperature of a color is relative. Here, Cobalt Blue is warmer than French Ultramarine Blue, but cooler than Cerulean Blue.

French Ultramarine

Cobalt Blue

Cerulean Blue

A different kind of color wheel

This color wheel is based on the particular pigments I use. The larger outer ring is comprised of my main transparent colors. These are great for making bright, clean washes of color and especially for glazing, in which layers of paint are applied over previously dried layers. Transparent colors allow the layers of color underneath to show through. The colors in between these main colors show how neighbors can be combined to create another closely related hue.

The inner ring shows four opaques. When used full-strength, opaque colors do not allow the colors underneath to show. However, opaques can be diluted to lessen their opacity. Notice the hues that result from mixing opaque neighbors. The small dot in the center is Turquoise. I use this color sparingly, usually for tropical colorations.

Colors can range from very opaque to very transparent, and there's always a little room for debate. I have always considered Payne's Gray transparent, but it depends on who you talk to and how it is used. With lots of water, it can be transparent; applied in thick dabs, it looks opaque. New Gamboge is basically transparent, but because it has little granules which can appear in a wash, some call this color semiopaque. Other semiopaques are Hansa Yellow and Cadmium Scarlet. These pigments have less white (or opaque pigment) in them. Transparent colors can create fuzzy edges when applied to the paper. Semiopaques will stay put and hold the edges, so I use them when I want this effect.

Most of the colors on my palette are nonstaining, which is a plus when I need to lift paint to make corrections. Quinacridone Gold and Permanent Rose are staining colors. Pigments with a slight stain include Aureolin, Cadmium Scarlet, Permanent Magenta and Brown Madder. The latter colors can be lifted easily, however, with lots of water.

Some colors are sedimentary, depositing small granules of pigment that are visible in a wash. These include Cerulean Blue, Cobalt Blue, New Gamboge and French Ultramarine. The blues are great for textural skies.

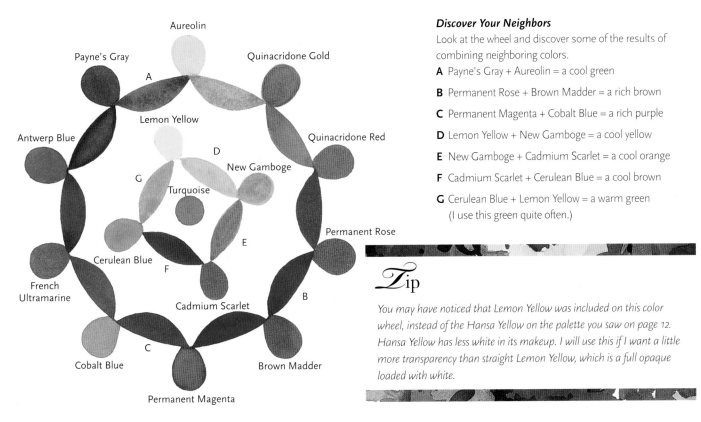

Discover Your Neighbors

Look at the wheel and discover some of the results of combining neighboring colors.

A Payne's Gray + Aureolin = a cool green

B Permanent Rose + Brown Madder = a rich brown

C Permanent Magenta + Cobalt Blue = a rich purple

D Lemon Yellow + New Gamboge = a cool yellow

E New Gamboge + Cadmium Scarlet = a cool orange

F Cadmium Scarlet + Cerulean Blue = a cool brown

G Cerulean Blue + Lemon Yellow = a warm green (I use this green quite often.)

Tip

You may have noticed that Lemon Yellow was included on this color wheel, instead of the Hansa Yellow on the palette you saw on page 12. Hansa Yellow has less white in its makeup. I will use this if I want a little more transparency than straight Lemon Yellow, which is a full opaque loaded with white.

Explore your transparent colors with charts

It is amazing to me to have so many choices just by taking the time to mix the right colors together. Instead of buying a dozen tubed reds, for example, try adding different pigments to base colors to see how many reds you can create on your own.

Understanding the makeup of your pigments—in particular, their temperatures—is key to mixing the colors you want. For example, adding warm yellow (such as Aureolin or Lemon Yellow) to bright reds (such as Permanent Rose or Quinacridone Red) will produce warm oranges. Adding cooler blues (such as Cobalt Blue or Cerulean Blue) to cool reds (such as Brown Madder) will produce cool purple tones.

Keep in mind that just because you can mix many versions of a color doesn't mean that you should use them all in a painting. Why have a dozen reds when a few will do? Limiting your colors will help you avoid confusion as you're painting, and your paintings will have more consistency and color harmony.

Seeing Red

Try this color chart. Paint a square of each of the reddish colors shown. Next to each square mix each red with a different yellow to form the top row. For the bottom row, mix each red with a different blue. Now look at the resulting oranges and lavenders. Notice that you get a slightly cooler result when using Permanent Rose, as it has a little blue in its recipe. Quinacridone Red creates warm and bright colors. Brown Madder grays the resulting colors. All of these results are great for glazing. All but Permanent Rose are nonstaining, meaning they can be lifted from your paper easily when making corrections.

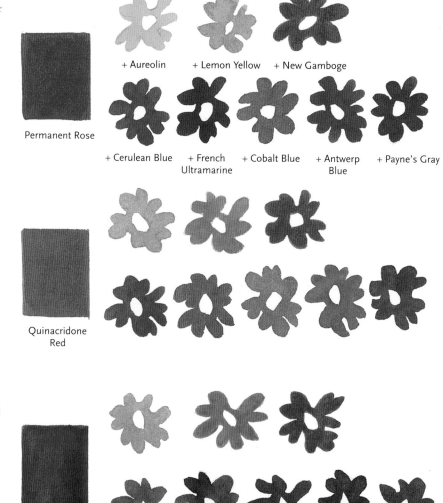

Permanent Rose

+ Aureolin + Lemon Yellow + New Gamboge

+ Cerulean Blue + French Ultramarine + Cobalt Blue + Antwerp Blue + Payne's Gray

Quinacridone Red

Brown Madder

22

*C*an I mix transparent colors with opaques?

"Can you successfully combine transparent colors and opaques?" is a question that is often asked by students. Opaques can be diluted to mix with transparents. Also, thinning an opaque with water and glazing over an underpainting will allow some of the underpainted color to show through. However, you can only glaze this thinned opaque once, as a second application will cancel seeing through the opaque. Using opaques full strength will completely cover the underlying colors. You might apply opaque finishing touches for the details of a painting.

The best way to use opaques is to create neutral colors—grays, browns and earth tones—or to add as final color notes on your painting. The term "mud" really means *unwanted* neutrals produced by overmixing and put in the wrong area of your painting. But you can use opaques and transparents to intentionally mix attractive neutrals and apply them appropriately in your paintings.

To see how various opaque and transparent colors react when mixed together, make a fat-over-lean chart, applying opaque colors over transparent ones.

*T*ip

Which pigments are transparent or opaque? Try this test. Paint a vertical strip of waterproof India ink on your paper. Then paint a horizontal strip of each color across the ink strip. Colors that remain visible over the ink are opaque, to varying degrees. Colors that seem to disappear over the ink are transparent.

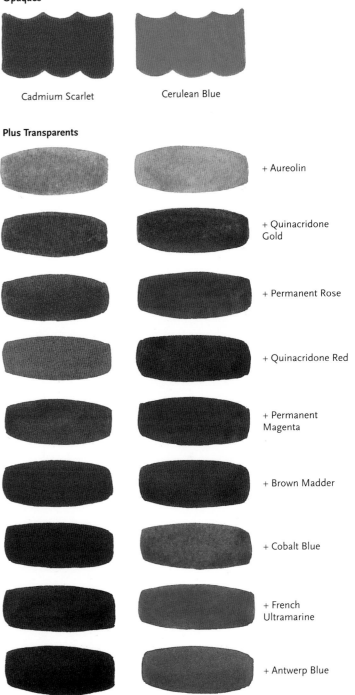

Opaques

Cadmium Scarlet Cerulean Blue

Plus Transparents

+ Aureolin

+ Quinacridone Gold

+ Permanent Rose

+ Quinacridone Red

+ Permanent Magenta

+ Brown Madder

+ Cobalt Blue

+ French Ultramarine

+ Antwerp Blue

Through Thick and Thin

Place a few opaque colors across the top of the chart. Under the opaques, make columns of the transparent colors mixed with the head opaque. Mix the transparents on the list in the order provided with the opaque at the top of each column.

Some colors are not dramatically affected by the opaques. In some cases the effect of the opaque is more noticeable, and in other cases the opaque color takes over completely. There is nothing wrong with any of the results. You simply need to make a choice for the effect you want.

Mix your own greens

Green can be a difficult color to work with, primarily because there are so many options available to us. Deciding what to use becomes a challenge. In working with tube greens, although the colors are attractive, I have found that most are staining and some are very opaque. Also, they seem to gray down quickly. For the benefit of myself and my students, I mix greens using non-staining, transparent colors in various combinations. The exception is the use of two opaques: Cerulean Blue and Hansa Yellow. Both work fine when diluted with water to cut the opacity. Try mixing greens using the following recipes. They will range from light and warm to dark and cool.

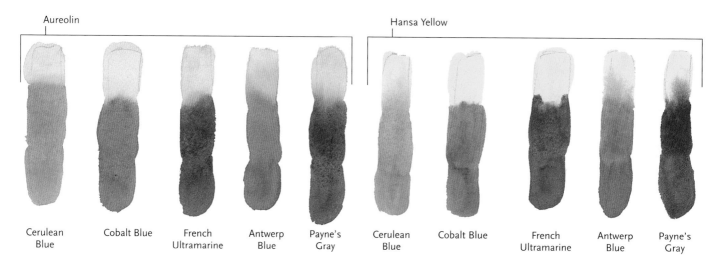

Aureolin

| Cerulean Blue | Cobalt Blue | French Ultramarine | Antwerp Blue | Payne's Gray |

Hansa Yellow

| Cerulean Blue | Cobalt Blue | French Ultramarine | Antwerp Blue | Payne's Gray |

Use Aureolin for the top of each brushstroke. Place a blue at the bottom of the stroke and let it blend with the yellow. The results are warm greens.

This row of brushstrokes starts with Hansa Yellow. Use the same blues at the bottom of each stroke. You will discover wonderful bright greens.

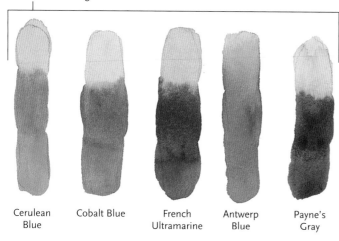

New Gamboge

| Cerulean Blue | Cobalt Blue | French Ultramarine | Antwerp Blue | Payne's Gray |

Quinacridone Gold

| Cerulean Blue | Cobalt Blue | French Ultramarine | Antwerp Blue | Payne's Gray |

Now combine New Gamboge with the same blues. The greens produced will be cooler and not as bright.

Change the yellow to Quinacridone Gold this time. Using the same blues as before will produce cool, earthy greens.

24

Why suffer colorless grays?

The transparent colors, including the newer quinacridones, allow you to achieve brilliant, clear color combinations. Once you have a great design with brilliant colors, the next important ingredient is the addition of subtle grays. These grays will offset or calm down certain areas of your painting, thereby enhancing the bright colors even more.

When painting florals, you can really exploit color, even grays. So just what kind of gray should you use? Hopefully one with life, instead of dull, flat colorless tones. By mixing your own grays, you will discover how you can make them lean toward one color or another, one temperature or another. When you mix two complementary colors together, they form a gray. Changing the ratio of each color in the mixture will give you various grays that are warm or cool in temperature.

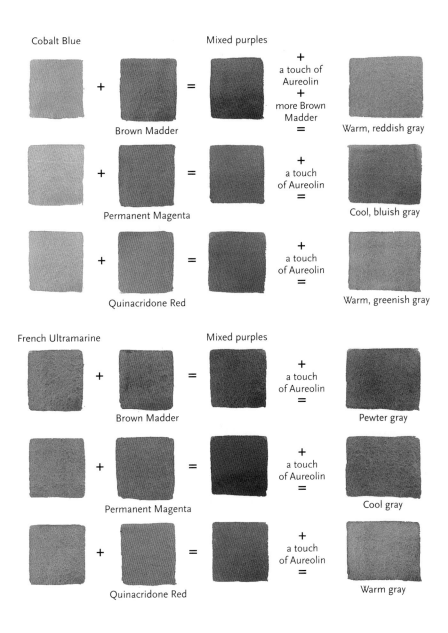

Subtle Grays
Using Cobalt Blue in all the combinations shown here will produce grays that are subtle, not intense. The base color for this example of grays is a mixed purple, created with Cobalt Blue plus each color shown. Then the complement of purple— a version of yellow— is added to gray the color. Adding additional yellow makes the gray warmer; adding additional blue makes the gray cooler.

Intense Grays
These grays have French Ultramarine in all mixtures. The resulting grays are richer and more intense. Varying the percentages of each color plus varying the values can give you many more varieties of grays using other colors on your palette.

Mixing earthy colors

I have omitted earth tone tube colors from my collection since I enjoy mixing from the colors on my palette. The color chart shown on this page is comprised of warm and cool earth tones made from opaques and transparents. They are nonstaining, liftable pigments.

Here a few things to keep in mind when mixing earth tones:

- A warm transparent yellow such as Aureolin or Quinacridone Gold will produce warm earth tones when mixed with a red such as Brown Madder.
- To achieve a middle-of-the-road earth tone that is somewhere between warm and cool, mix a cool yellow such as New Gamboge with Brown Madder or Permanent Magenta.
- The biggest adjustment in mixing earth tones is the introduction of Cerulean Blue mixed into the reds and blues. This produces grays due to the opaque Cerulean in the mix. They will also be cool in temperature.

New Gamboge +
Quinacridone Gold

Quinacridone Gold

Cerulean Blue +
Cadmium Scarlet

Antwerp Blue +
Cadmium Scarlet

New Gamboge +
Brown Madder

Quinacridone Gold +
Brown Madder

Cerulean Blue +
Brown Madder

Antwerp Blue +
Brown Madder

New Gamboge +
Permanent Magenta

Quinacridone Gold +
Permanent Magenta

Cerulean Blue +
Permanent Magenta

Antwerp Blue +
Permanent Magenta

New Gamboge +
Payne's Gray

Quinacridone Gold +
Payne's Gray

Cerulean Blue +
Payne's Gray

Antwerp Blue +
Payne's Gray

How to avoid overmixing

Nothing will ruin a watercolor more quickly than mixing too many colors together. Perhaps you might have three or four pigments in one combination for a wash. This will lead to flat neutrals, or mud. You can combine two or three colors successfully if you adjust the ratios of each color. One should dominate the mix.

Another common mistake is to apply too many glazes. You might be doing this to build value and detail; however, it can get you into trouble if overdone. The clean transparent washes can be lost as you work toward the finish, resulting in a single-value painting.

Poor Color Sketch: Too Many Ingredients

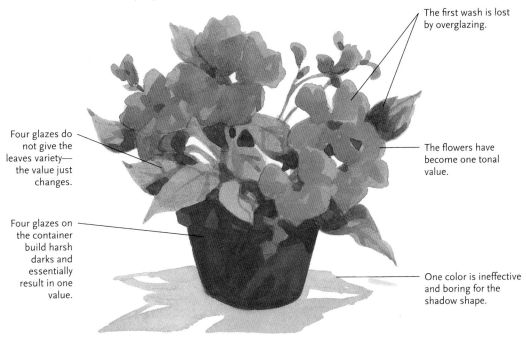

The first wash is lost by overglazing.

Four glazes do not give the leaves variety— the value just changes.

The flowers have become one tonal value.

Four glazes on the container build harsh darks and essentially result in one value.

One color is ineffective and boring for the shadow shape.

Improved Color Sketch

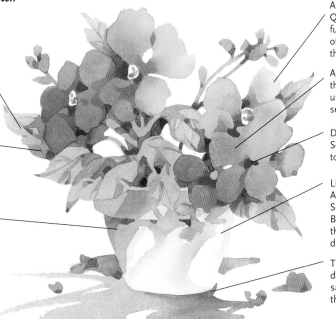

The first glaze for the leaves is a light green mixed from Aureolin and Cerulean Blue.

The second glaze is a richer value of the mixed green.

Lavender (Cobalt Blue and Brown Madder) plus Aureolin forms a livelier gray.

Aureolin and Quinacridone Red fuse into each other for variety in the flowers.

A second glaze of the same colors is used sparingly to separate petals.

Dabs of Cadmium Scarlet are added to finalize.

Light washes of Aureolin, Cadmium Scarlet and Cobalt Blue on the pot allow the flowers to remain dominant.

The shadows are a darker value of the same gray used for the pot.

PALETTE

Aureolin
Brown Madder
Cadmium Scarlet
Cerulean Blue
Cobalt Blue
Quinacridone Red

Use four glazes for a complete flower

In watercolor, glazing is used to build values. It becomes the glue that holds your painting together. This is a fun experiment using only four glazes to paint a complete flower. The palette is limited so that extra colors won't muddy the mix. When using an opaque to glaze—in this case Hansa Yellow and Cadmium Scarlet—you need to use enough water to lessen the opacity.

MATERIALS

Paper
140-lb. (300gsm) cold-press

Watercolors
Antwerp Blue
Cadmium Scarlet
Hansa Yellow
Quinacridone Red

Brushes
No. 7 rounds

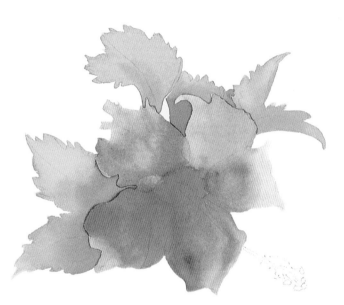

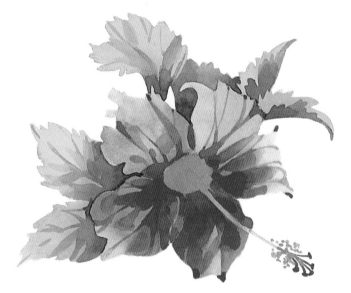

1 Draw the Flower and Apply the First Glaze
Sketch your flower with a light pencil line. Paint the petals with a light wash of Quinacridone Red. While the wash is damp, drop in dabs of Hansa Yellow on the petal tips, then add a pinch of Cadmium Scarlet in the central part. For the leaves, mix Hansa Yellow and Antwerp Blue for a light green wash, then drop in dabs of yellow on the tips. Add a little more blue near the base of the leaves closest to the flower. Let it dry.

2 Add the Second Glaze
Glaze an additional light value of Quinacridone Red on the petals. It is important to allow some of the first wash to remain. If you want a little more orange on the petals, glaze a delicate wash of Cadmium Scarlet and Hansa Yellow on top. Add another glaze of the same green mixture used in step 1 on the leaves to increase their value. Paint the flower stamen, repeating the flower colors. Let it dry.

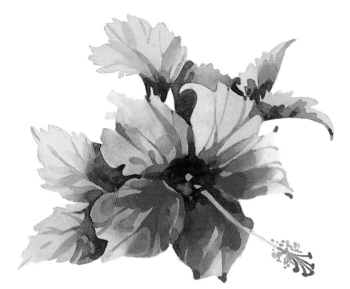

3 Apply the Third Glaze
Glaze dark shadow shapes on the leaves using a purple mixed from Antwerp Blue and Quinacridone Red plus Hansa Yellow, which will form a nice gray. Paint the dark centers of the flowers using the same mixture in a much thicker consistency. Feather out to soften the edges.

4 Finish With the Fourth Glaze and Details
The final glaze to add is a light wash of Hansa Yellow over the petals and leaves to connect all of their values, creating unity. Add any final details you would like, but do not overdo it.

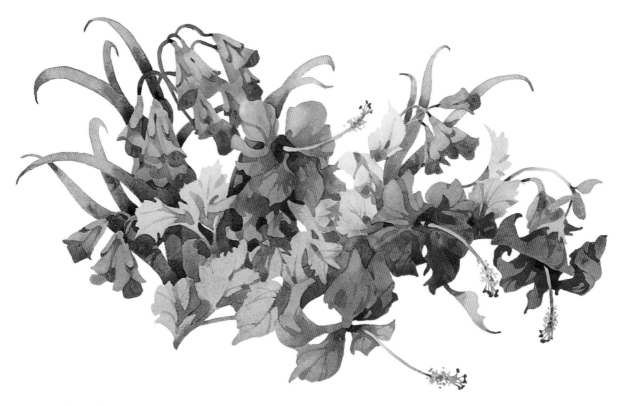

Putting It All Together
Once you have practiced glazing for individual flowers, put them all together for a larger painting. This painting is all about red and green working together in harmony. It was created with a palette of only five colors: Aureolin, Cadmium Scarlet, Cerulean Blue, Cobalt Blue and French Ultramarine. You should only need two or three glazes of clean washes for good results.

ISLAND BEAUTY
14" × 22" (36cm × 56cm)

More practice with a limited palette

The following exercises will help you simplify your paintings by using only two or three key colors. This kind of restraint will assist you in becoming more selective with your color choices. It also presents a relatively easy way of achieving color harmony. Using fewer colors will help ensure a harmonious color scheme.

You'd be surprised at the variety of colors you can have when using a "limited" palette. When you approach a full painting, changing the values of the key colors gives you additional tones to work with. Glazing colors over one another can create entirely new unexpected colors—what I like to call "bonus colors." They can also be intentionally mixed from the key colors to add an additional color change to the painting.

When planning a painting I often ask, Is this painting mainly about oranges, blues, purples or another color family? In other words, does one color dominate the painting? Minding this concept will give you consistency in your work instead of chaos.

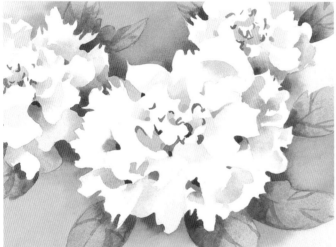

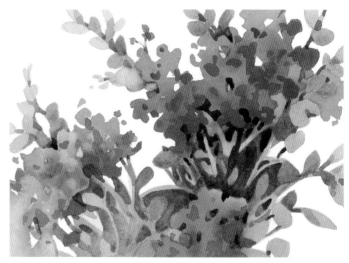

Complementary-Color Challenge 1

The key complementary colors are orange (Cadmium Scarlet) and blue (Cerulean Blue). Follow these steps:

1 Sketch a few white peonies.

2 Add a few light washes of orange on the flowers, leaving large white areas.

3 Add background washes of orange and blue.

4 Combine the key colors, producing a gray for shadows.

5 Finish the flowers with dabs of orange in their centers and a few blue accents as well.

6 Add blue to the leaves. When they're dry, glaze a little orange on the leaves, giving you a bonus color.

Complementary-Color Challenge 2

The key complementary colors are red (Quinacridone Red) and green (Aureolin plus French Ultramarine). Follow these steps:

1 Sketch some geraniums.

2 Paint a red wash on the flowers. Let it dry.

3 Place a light wash of the mixed green on the leaves and solid areas. Let it dry.

4 Add midtone values of the same green.

5 Add dabs of rich red on the small petals.

6 Add darker greens where needed.

7 Mix the key colors together to produce the darkest values.

8 A final glaze of light red over the green areas will produce orange, a bonus color. This happens because of the yellow within the green.

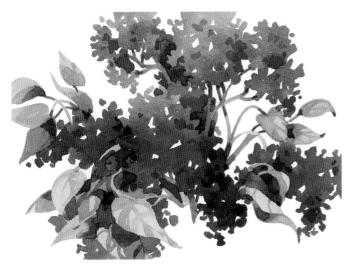

Analogous-Color Challenge 1

The key analogous colors are green (Aureolin plus French Ultramarine) and purple (Quinacridone Red plus French Ultramarine). This sketch will be cool in temperature. Follow these steps:

1 Sketch the lilacs and leaves.

2 Paint the lilacs with a light purple wash.

3 Mix green with more yellow in the mixture and paint the green leaves.

4 The stems are yellow and red mixed. This bonus color results from mixing two of the colors (Aureolin and Quinacridone Red) needed to form the key analogous colors. It provides a nice color change while still relating to the rest of the painting.

5 Glaze a little French Ultramarine over the leaves to darken their value.

6 For a natural dark on the leaves, mix green and purple together for a rich, neutral tone. Watch the ratio.

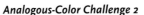

Analogous-Color Challenge 2

The key analogous colors are yellow (Quinacridone Gold) and orange (Cadmium Scarlet). This sketch will be warm in temperature. Follow these steps:

1 Sketch a few sunflowers.

2 Paint a light wash of yellow over the flowers. Let it dry.

3 Add more washes of yellow to change the value.

4 To darken the petals, glaze over them with a mixture of the key colors.

5 The centers of the flowers are rich values of both key colors, applied wet into wet. When they're dry, add pure orange for details.

6 Add final notes of darks using a mixture of the two key colors.

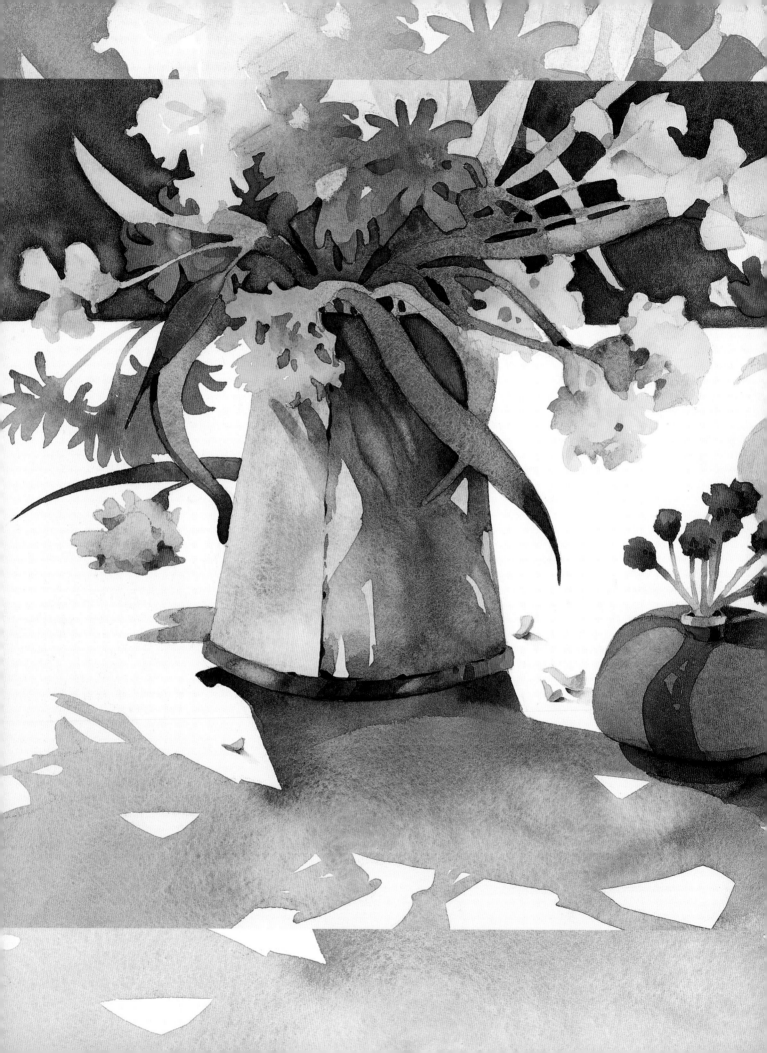

Developing a Great Composition

Designing your composition is perhaps the most difficult part of the painting process. There are so many things to think about that it can be overwhelming. You need to organize your thoughts in order to simplify the search for the perfect painting.

Learn how to dramatize your work by selecting the best light for your subject. Discover how to produce better shadow shapes through design and color. The all-important value study is a road map for the development of your painting; let's travel the road together. Push yourself further with the addition of color sketches. Finally, look at reference photos and determine how they can be improved upon for a painting. Whether you are working from real life or photos, your goal is to look for the best response to the subject. Learn how to interpret your research and exploit the color for the best results.

FLORAL SHADOWS
14" × 21" (36cm × 53cm)

How light affects form and shadow

The advantage of arranging still-life setups is that they never move and are only affected by the lighting you choose. Once you have a pleasing arrangement in mind, it is time to plan your composition. The placement of your lights can be the very thing you need to ensure a successful painting.

Try the following lighting situations to understand how light affects form and shadow. With practice you will be in a much better position to select the lighting that best describes what you want to say.

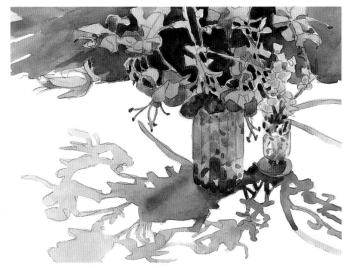

Overhead Light

Shadows can act as an important design element. Overhead lights can be moved to place the shadows wherever you like. Move the light a little to the left or right, up or down to see the different shadow shapes that form. Shadow shapes lighten in value as they extend from the subject.

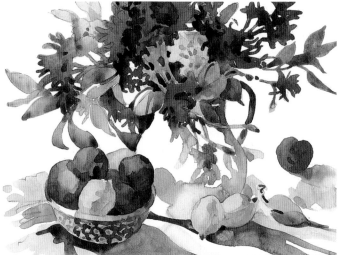

Backlight

For dramatic effects, try shining one light from behind your subject. The color becomes very rich, and there are high contrasts between the lights and darks.

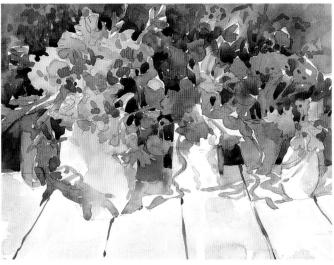
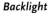

Sidelight

Light coming from the front and one side (here, the left) will showcase the bright colors on the flowers and leaves. More gradual shifts in value occur. To dramatize the subject, try a rich, dark background, keeping the colors cool in temperature. This sets quite an exciting stage.

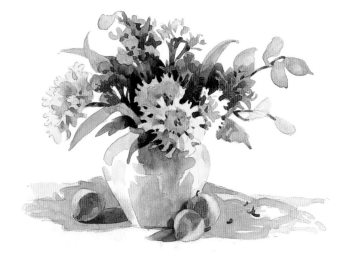

Light From Two Sides

Both sides of the subject are lit, causing lighter values on each side. The shadow shapes and darks become centralized. Don't be confused by the shadows on both sides of the tablecloth; each light creates its own set of shadows. The shadows cast by the peaches may at first seem incorrect, but they're not: Their different directions result from the unique lighting.

Sculpt a painting with values

It is difficult sometimes to think in three dimensions when working on a flat piece of paper. The drawing comes first and looks flat when finished. We look at our subjects and have to ask ourselves, "Just how do I make it look real?" The all-important tool of well-planned lighting can best answer that question. The lighting will help you discover form by creating value changes. Lights, midtones and darks, plus hard and soft edges, are the artist's sculpting tools. Aim to make your viewer feel the space in your painting.

Don't Let an Overcast Day Stop You

This bucket of flowers is so colorful and bright that it is just begging to be painted. The sky was overcast, resulting in less direct light falling on the subject. When this happens, you can see all of the pure or local colors of your subject, as they are unaffected by highly contrasting values. Do not discount gray days; they just mean that we can mentally choose the lighting that we want to make the painting work.

Plan Your Values

For the value study, I imagined strong sunlight shining down on the flowers. The lightest values have become the dominant value. The midtones cover a little less territory but are nevertheless important—they are the glue that binds the lights and darks. A small amount of darks is placed next to the lightest values for contrast, emphasizing the focal point.

Let the Sun Shine In

The objective here is to place warm tones in light areas and cool tones in midtone areas. Aureolin and Permanent Rose were washed over the flowers. The same yellow was combined with Antwerp Blue for the leaves. This same mix was cooled with Cobalt Blue, then added to the leaves. The container is a wash of lavender (Quinacridone Red and Cobalt Blue) plus Aureolin for the gray. This gray is repeated in the shadow areas. The chosen lighting brings out the form that was lost in the photo.

PATIO GUEST
14" × 12" (36cm × 30cm)

ℐimplify lights and darks to see patterns

Designing your floral composition involves deciding what shapes will go where and how many you want in the painting. This does not involve only the obvious shapes—the flowers and other components of your setup—but the overall shapes or patterns of light and dark that make up the scene. Organizing your shapes into light and dark patterns can help you simplify a seemingly complex scene into an eye-pleasing composition.

Look at the shadow areas that are caused by the lighting. These shadow shapes should factor into your design. Bear in mind the other effects of lighting to simplify your composition. Details become less visible as they move away from the light. You will see more lost areas and cooler tones. And even in areas where the lighting reveals the form and detail of nearly every petal, leaf or stem, that doesn't mean you have to paint it all.

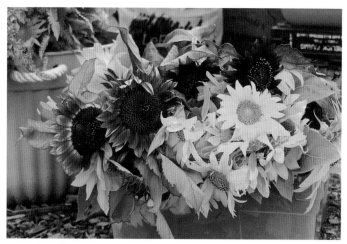

Reference Photo
Sunflowers are so powerful as a design, partly due to their colors. However, there is so much going on in this photo that it becomes confusing. In order to have a good composition, we need to rearrange, edit and make size adjustments. The flowers' colors vary from yellow and orange to deep brown. Let's exploit these colors through the use of lighting and by creating good contrast.

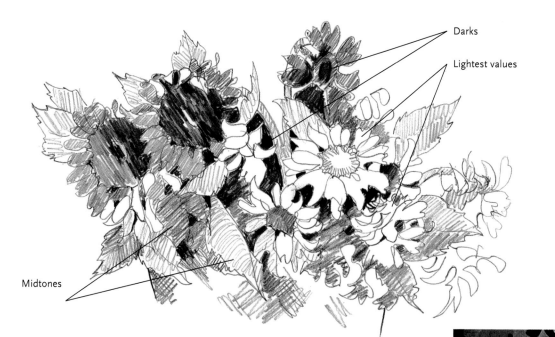

Darks

Lightest values

Midtones

Design With Value
This three-value study helps to simplify things. Light values on petals and leaves are carefully selected. The midtones include a large area of leaves, flowers and shadows. Darks are placed around the lightest flowers that are so important to the design.

𝒯ip

You can easily find value patterns by taking black-and-white photos of your subject. The values are clearly stated, just like in our favorite "old" movies.

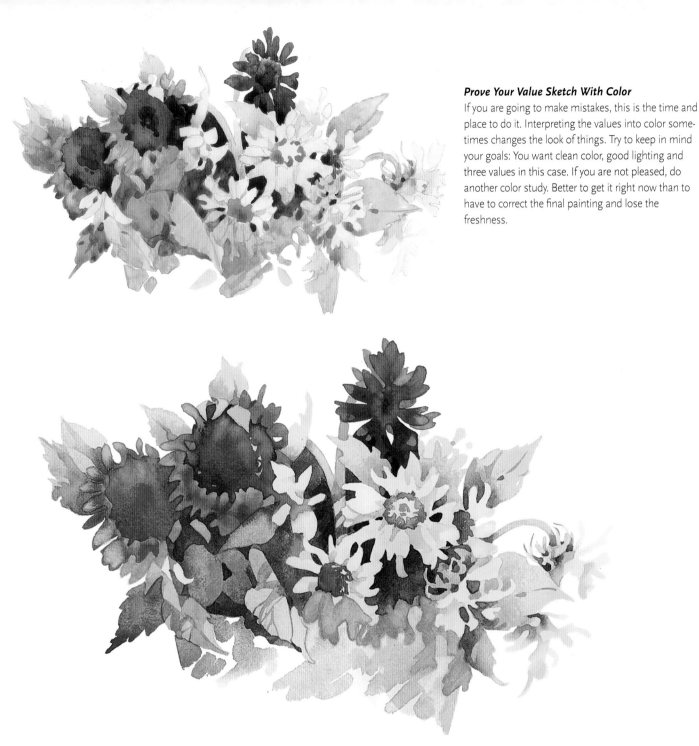

Prove Your Value Sketch With Color

If you are going to make mistakes, this is the time and place to do it. Interpreting the values into color sometimes changes the look of things. Try to keep in mind your goals: You want clean color, good lighting and three values in this case. If you are not pleased, do another color study. Better to get it right now than to have to correct the final painting and lose the freshness.

Working From Light to Dark for the Finished Painting

1 Flood the first values of light yellow (Aureolin plus a little Hansa) over the designated flowers and leaves. Add Cerulean Blue to the leaves, turning them green.

2 Apply the midtones next. This includes the large sunflowers, which should be painted with Permanent Magenta, Brown Madder and Cadmium Scarlet. Apply the cooler greens with a mix of Aureolin and Cobalt Blue.

3 Mix Brown Madder and Permanent Magenta for the few small darks. The resulting purple complements the yellow tones.

4 Make final adjustments by glazing soft washes of lavender (Quinacridone Red plus Cobalt Blue) on the bucket and the yellow petals in shadow. Darken a few petals on the yellow sunflowers with New Gamboge.

FARM HARVEST
11" × 15" (28cm × 38cm)

PALETTE
Aureolin
Brown Madder
Cadmium Scarlet
Cerulean Blue
Cobalt Blue
Hansa Yellow
New Gamboge
Permanent Magenta
Quinacridone Red

Design with color temperature

When composing a painting it is important to select the overall dominant temperature. This helps to create interest and set the mood. Regardless of what your reference photo shows, you can change the color and lighting to reflect what you want to express.

Play with the ratio of warm to cool in your paintings. Just make sure that the ratio is unequal; equal amounts of warm and cool will quickly bore your audience.

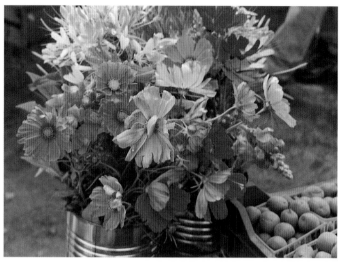

Reference Photo

These cosmos are basically the same color. The light shining down shows us the form of each petal. How much of the subject you want to lose or find becomes your choice. It is now time to edit. Look for patterns that best describe the flower shapes.

A Temperature Plan

My plan here is to have warm and cool colors that will reflect the lighting. The dominant temperature is on the cool side. The lighter flowers are washes of Permanent Rose. The flowers away from the light are washes of the same red cooled with Cobalt Blue. They become part of the largest value of midtones, including the shadow areas. A mixed green for the leaves is warm in the light, but cooled with Cobalt Blue in the shadows. To dramatize the focal point, I placed rich darks around the lightest flowers.

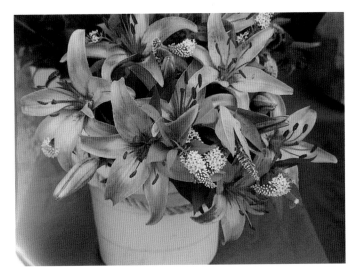

Reference Photo

Here is another example of flowers that are mostly pink and pale yellow. They make a great design; however, we have to change the lighting to more effectively offset selected petals. What would your choice be? Which flowers should become less important?

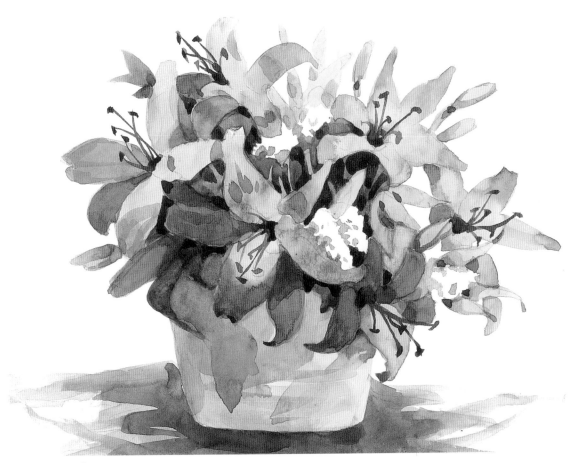

Make the Sacrifice

My answer for this sketch is to sacrifice some of the lovely warm colors on some of the lower flower petals. The dominant temperature is on the warm side, but a few cools are needed for balance. I used the same pigments as in the previous sketch. Imagining the light source close to the subject creates bright and dark contrasts. Knowing this, I painted rich, warm Cadmium Scarlet over the flowers and bowl. The shadow shape is warm as well. The very cool tones balance the warm tones, and with rich darks added I simplified the design and took the best advantage of the lighting. Had I followed the photo, I would have had a monochromatic sketch.

Turn on the lights for drama

How you should light your subject matter depends on what you wish to express. When you are outside in daylight you can take advantage of the current conditions. It could be sunny, overcast or foggy. Is the atmosphere warm or cool? Time of day offers many varieties of shadow shapes. All of this affects your work. Think about this when you light a setup in your studio.

Try a series of paintings of the same subject, changing the lighting each time you start a new piece. Sometimes our first choice is not the best. Let the lighting show you color and value. Do not be impatient with repeating the same subject matter; you may discover better results.

On the following pages are examples of a couple of still-life scenes approached with two different lighting plans for each.

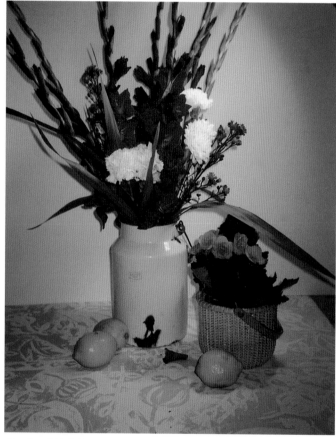

Overhead Lighting
The lighting on this floral setup is overhead on the right side. Notice that the large shadow shape on the fabric connects the white jug and basket. Shadows are a useful tool to connect elements. I call this the "tie-in connection."

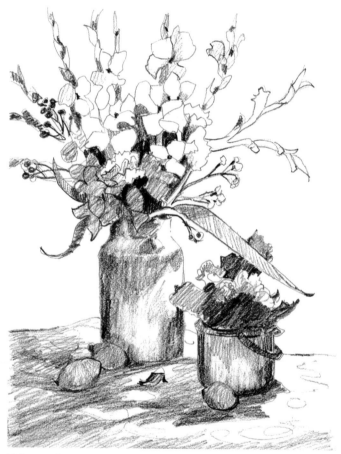

Value Study
This value plan is essentially made up of three values: the light on the top of the flowers, a small part of the fabric and the white jug; the midtones, which become the dominant value in this design; and the darks, which are very important even though they are small in ratio. The lightest lights are emphasized by the darkest darks.

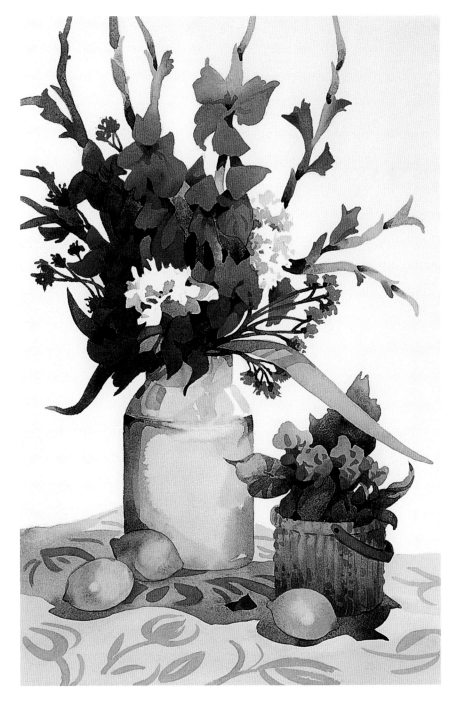

Still-Life Setup 1, Version 1

1 Apply light washes of Permanent Rose and orange (Permanent Rose plus Aureolin) over the gladiolas in the light. While the flowers are still wet, add a little Cadmium Scarlet for variation.

2 Paint the lighter stems wet into wet with Aureolin and Cerulean Blue, letting them run into the damp flowers.

3 The rest of the flowers are midtones. Paint them with a wash of Permanent Rose and Permanent Magenta to cool them.

4 Paint the midtone stems with a mixture of Aureolin and French Ultramarine, cooled with Permanent Magenta. Paint the leaves in the basket using the same colors.

5 The overhead light caused a lot of shadows on the white jug, basket and fabric. Use Cobalt Blue and Permanent Rose to mix a lavender, and then gray it by adding Aureolin. Mix a large amount of this color to cover all of the shadow shapes.

6 Add dabs of Permanent Magenta and French Ultramarine as final darks around leaves inside the jug and basket.

GLADIOLAS I
22" × 15" (56cm × 38cm)

PALETTE

Aureolin
Cadmium Scarlet
Cerulean Blue
Cobalt Blue
French Ultramarine
Permanent Magenta
Permanent Rose

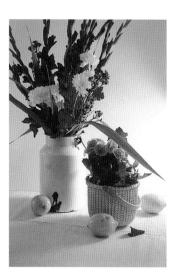

Backlighting

Now the light has been placed behind the subject and to the lower right. This creates rich contrasts. Notice the warm tones on the flowers and lemons that are in the strongest light. The rest of the subject has been cooled down in temperature. The shadow shape also reflects warm and cool temperatures.

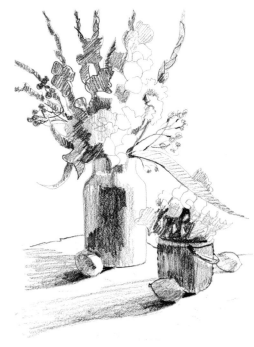

Value Study

This value plan is easy to determine. This light pattern creates strong contrasting values by having the darkest value next to the lightest value. When you look at the left side of the subject, see how the midtones become softer and cooler. Notice how the darks are centralized in the jug and basket.

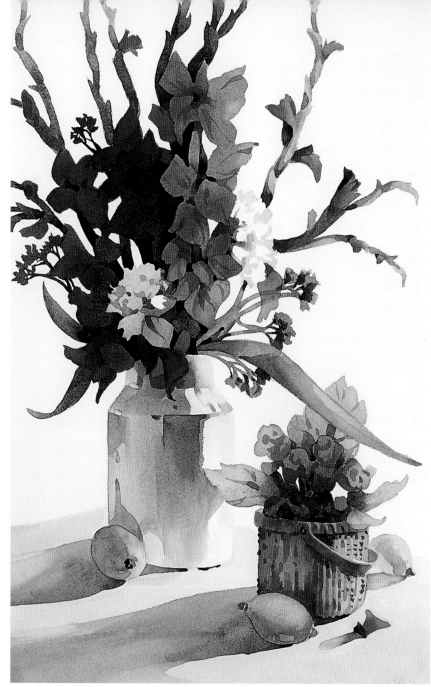

Still-Life Setup 1, Version 2

We'll use the same colors that were applied in the first version, with the addition of Hansa Yellow.

1 Paint light washes of Permanent Rose and orange (Permanent Rose plus Aureolin) on the lightest flowers wet into wet, connecting each flower.

2 Paint the small flowers in the basket with a wash of Aureolin and Cadmium Scarlet, wet into wet.

3 Paint a light Hansa Yellow wash over the fabric, basket, lemons and green leaves.

4 Add a wash of Permanent Rose, Permanent Magenta and Cobalt Blue to the rest of the gladiolas.

5 The green stems on the left and above the flowers are a mixed green of Aureolin and French Ultramarine in cool tones.

6 The gray shadow of the jug is a mixed lavender (Permanent Rose plus Cobalt Blue) with a little Aureolin. Use this wash on the fabric as well, varying the color ratios.

GLADIOLAS II
22" × 15" (56cm × 38cm)

42

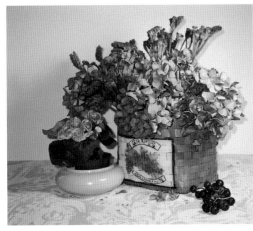

Sidelight

I like this particular way of lighting objects. It can be dramatic and colorful. It is also less confusing if you paint it correctly.

The light coming in from the front right clearly reveals petal forms, basket patterns and some fabric patterns. Remember that you will lose shapes and details as you move away from the light source. This helps in editing out where you need to.

Value Plan

This time I used a 4B pencil for the value sketch so I could easily achieve very dark values. The light patterns become the dominant value. Midtones gray down the left and center of the subject. The focal point, which is surrounded by darks, has the most details. I kept the detail in the fabric pattern simple so it wouldn't distract.

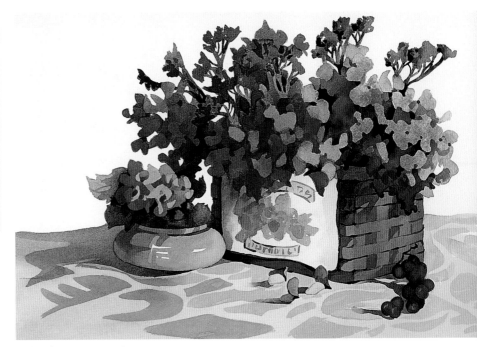

Still-Life Setup 2, Version 1

1 Paint all of the hydrangeas with light washes of Cerulean Blue and Permanent Rose.

2 Mix Permanent Rose and Aureolin for the orange flowers, bowl and basket. While the wash is still wet, drop in a little Hansa Yellow on the right side of the basket and bowl to reflect the lighting.

3 Paint a light wash of Aureolin over the fabric.

4 Apply a mixed green of Aureolin and Cerulean Blue for the leaves.

5 Now that you've established the light patterns, paint the large area of midtones—which include two-thirds of the hydrangea—using Permanent Rose, Permanent Magenta and Cerulean Blue.

6 Once this is dry, add a gray wash (Cobalt Blue and Permanent Magenta plus Aureolin) to further cool down and push back this area.

7 Paint a minimum of detail for the basket front, the grapes and the scattered petals on the fabric.

8 Add gray shadow shapes to the left side of each element using the same gray mixture in step 6.

9 Finally, add rich darks next to the lighter flowers. A few details finish the painting. Keep the fabric pattern simple so that you can see the color change from warm to cool.

HYDRANGEAS I
15" × 22" (38cm × 56cm)

PALETTE

Aureolin
Cerulean Blue
Cobalt Blue
Hansa Yellow
Permanent Magenta
Permanent Rose

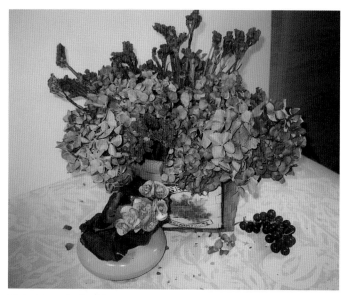

Light From Both Sides

This photo shows the subject matter at a different angle. I used the same drawing from the previous example to repeat the same design, but I used different lighting.

See how the light on the left and right sides clearly describes the floral forms. The light on the bowl is very subtle and appears to have one tone. This type of lighting situation can confuse you as the shadows go in two directions. This can be clarified in a value plan.

Value Plan

I placed light values on the left and right sides of the hydrangeas, orange flowers and bowl. The basket remains light with less detail. The center of the hydrangeas becomes darker and cooler. The darks are placed on both sides of the flowers next to the lightest petals. The fabric appears pale in front but will darken in value as it moves away from the light. The shadows under the bowl and grapes are kept light to lessen their importance.

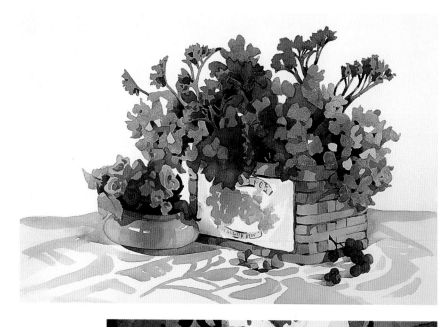

*T*ip

When you light both sides of your subject, the center of the elements becomes midtone areas that are less detailed and cooler in temperature. Think of it this way: Do a pencil sketch of anything. Then fold the sketch in half. If you were to paint with this lighting choice, both the left and right sides of the sketch would be painted in the same colors and values. The fold or creased area of the sketch would be the midtone section.

Still-Life Setup 2, Version 2

We'll use the same colors that were applied in the first version, with the addition of Cadmium Scarlet and French Ultramarine.

1. Paint the lightest values of the hydrangeas with light washes of Cerulean Blue and Permanent Rose.

2. Paint the green stems within and outside of the basket with a mix of Aureolin and French Ultramarine.

3. While the stems are still damp, connect them to little lavender flowers painted with Permanent Rose.

4. Paint the small orange flowers with Aureolin and Cadmium Scarlet. When they're dry, add the leaves with light mixes of Aureolin and French Ultramarine.

5. Paint the basket and the bowl with light washes of Aureolin and Cadmium Scarlet. Drop in a little Hansa Yellow to the right side of the basket and both sides of the bowl to reflect the lighting.

6. Paint the fabric pattern with the same color mixture used in step 5. The pattern has more color in front and less on the left and right sides due to the lighting.

7. Paint the midtone section in the hydrangeas with a gray mixture of Permanent Magenta, French Ultramarine and Aureolin.

8. Combine the complements red (Permanent Rose) and green (Aureolin plus Cobalt Blue) to form the gray for the orange flowers.

HYDRANGEAS II
15" × 22" (38cm × 56cm)

44

Light on still-life components

Add vegetables, fruits, fabrics, decorative bowls and other items to spice up your floral arrangements. This makes for a much more interesting and colorful design. Just remember that the focal point should contain the most contrast. When you paint the other elements, they should support the main subject and not take away from it.

Lighting will affect these additional elements in various ways depending on their form and texture. Let's look at a few examples.

The light source is coming from the top left.

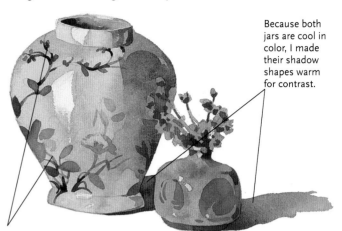

Because both jars are cool in color, I made their shadow shapes warm for contrast.

The decorations on the gray jar have more value and definition in the light. They become more diffused away from the light.

The greens are warmer in the highlight of the folds.

The fabric pattern helps to reveal the folds that occur. The pattern should be adjusted to follow the folds and creases.

The pattern colors cool down and are less important in the shadows.

The light source is coming from overhead.

I painted a warm and cool side on the white bowl. When it was dry, the rich darks in the shadow shapes were added.

The light source is coming from the left behind the subject.

I kept the strawberries within the bowl rich in color, while the other berries are softer so they will not compete.

The green apples have subtle value changes to lessen their importance.

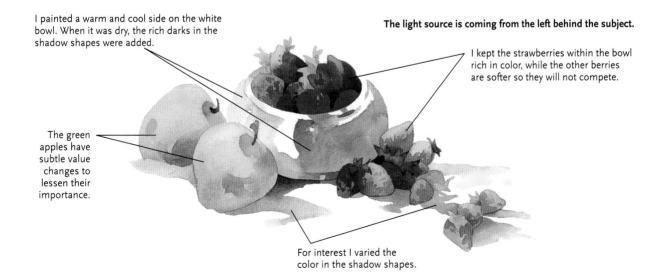

For interest I varied the color in the shadow shapes.

Strengthen your compositions with contour drawing

A contour drawing is one continuous line around the outer edge of your subject. This allows you to see if the overall composition fits properly on your paper, without the distraction of unnecessary drawing inside this shape. Once the contour drawing is completed, you can compose the elements within the contour shape.

Consider not only the positive shapes of your subject, but the negative shapes or spaces within and around them. If you create good negative shapes, they in turn define good positive shapes.

Reference Photo
This is a very busy flower arrangement. Take a look and decide just how much is important to you. Should you edit or add anything?

Contour Edges
On medium-weight sketch paper and using an HB pencil, do a light drawing of the subject. Make any changes you like. Now check your design to see if you made good choices. Using an ultra-fine-point marker, do an ink contour line around your drawing. When finished, take a look at the edges. Are they interesting and descriptive? This will also reveal background shapes.

Think Inside Out
Repeat your light pencil drawing. You already know that the outer edges have a good design. Now you need to get inside the subject and find all of the negative shapes. Use the marker, and this time do not think of positive shapes—ink only the spaces that surround them. If you end up with just a few spaces, then add more. They are there; you just have to look.

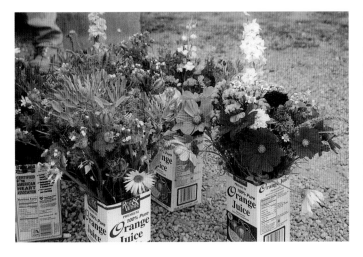

Reference Photo

This time the setup is three containers of flowers—quite a jumble of great shapes. Where does one end and the other begin? If you were to paint this, which flowers or colors would dominate the composition? To design this setup, think of the flowers and containers as being elastic—something you can stretch or pull as you fit it to your paper. At the same time be sure to consider contours, negative shapes and edges.

Detailed Drawing

Try a different paper, maybe 90-lb. (190gsm) paper, and a soft-lead (4B) pencil. Do a full drawing with a sharp pencil. Ask yourself the following questions, keeping in mind the goals for this design: (1) Are the contour edges well designed? (2) Does my drawing reflect a dominant shape? (3) Have I eliminated unnecessary things? (4) Are the negative shapes within the design interesting?

Contour Drawing

You have completed your full drawing and are ready to start your painting. Wait a minute! Check to see if it will work. Do a contour drawing of the entire plan, then add those great little negative shapes. A contour drawing is like seeing an X ray of your design—it can help you diagnose compositional problems before you pick up your paintbrush.

Try on different value plans

There are so many choices when it comes to the value plans for compositions. Regardless of the subject matter, you need to think about this step carefully. What do you want to say about your subject? After you've completed a contour drawing, try on a couple of different value plans for your subject. Now that you know how different types of lighting can affect your subject, you can experiment with several value plans without necessarily shooting a different reference photo for each type of lighting.

Contour Drawing

Start a contour drawing of your still life using an ultra-fine-point marker. Use this sketch as the basis for each value plan. Some ink lines are heavier than others; this helps to outline or separate the elements. Try not to add petals and details; they can confuse things and are not needed in a sketch.

Value Plan 2

Repeat the sketch again, this time with the light placed overhead and shining straight down on the subject. The tops of the petals, flowers and some leaves are light in value. Some leaves begin to pick up midtones and darker values. The darkest values are on the leaves and stems closest to the vase.

Value Plan 1

Repeat the contour drawing on sketch paper with a 2B pencil. Remember to simplify the lines and forget details. The light source is coming from the right and hits midway down the subject. Add values by shading in light tones, midtones and darks. The shadows and stems in the glass vase should be midtone to light. Notice the darks are placed near the lightest values.

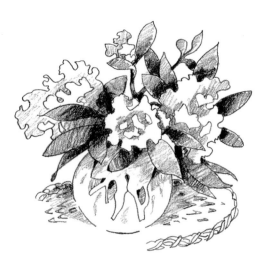

Value Plan 3

Make another sketch, this time with the light placed in front of the subject. We often choose this lighting, as it seems to be the easiest plan to use. The light values are predominant, followed by midtones and a few selected darks—not the most interesting choice. Look at all three plans and see which one you prefer. There are no wrong choices, just different options.

Evaluate reference materials

Part of using reference materials correctly is knowing what *not* to use. Rarely can you take a reference photo at face value and simply re-create it for the perfect painting.

What typically happens when you try to copy a photo? Look at this example.

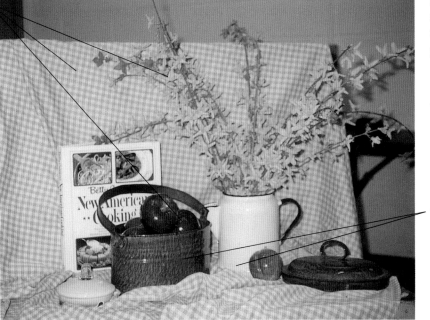

The color shows the full spectrum of red, yellow and blue. It is very confusing.

The lighting does not show-case anything.

Reference Photo
Although this is a nice photo, it is unacceptable as a composition for a painting.

It lacks a dominant shape and has no focal point.

There are too many elements. Is this scene about flow-ers or pots and apples?

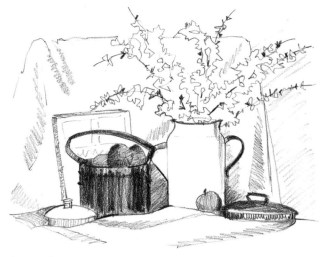

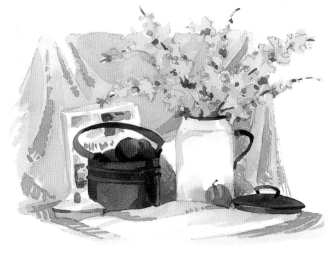

Value Study
This value study is based purely on what the photo shows. There are too many lights and darks and not enough midtones. We'd be better off trying several different value plans. This is the road map to make your colors work.

Color and Value Sketch
This composition of values and colors has poor ratios. It shows two grays, two whites, two oranges, one yellow, one red and one blue—a fairly even and thus boring distribution of hues. Where is the predominant color? For success, select a more limited palette and use more closely related colors.

Enhance poor research

Sometimes we are so influenced by our photo research that we are afraid to depart from it, even when that's what is best for the painting. Also, we forget that the photographic eye cannot possibly capture everything that the human eye sees. In fact, photos cannot give you all the color nuances, and photos tend to overdarken values.

Sometimes a photo can be improved quite easily by adjusting the values and enriching the color to better reflect the scene that we remember or the scene that we imagine it could be.

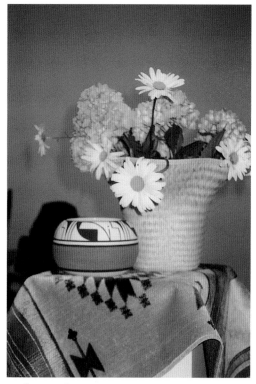

Contour It
Use a fine-point marker to do a contour sketch. Spread out the design to fill the paper. Create a dominant shape, and add other elements for more interest in your composition.

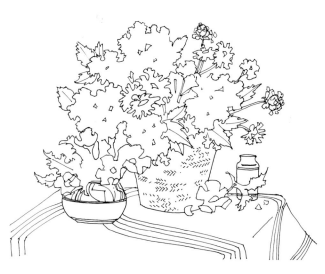

Look Beyond
This subject matter may be interesting, but the arrangement is poor. The flowers need to be fuller and the other elements more spread out. There could be better lighting. Create better photography or change it in your composition.

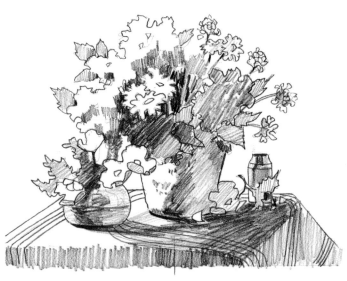

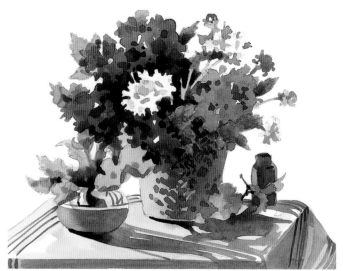

Lighten Up
Select lighting with one light source for dramatic effect. The result is a value plan with strong contrast. Pencil in darkest values next to light areas. The midtones are next. They become local color, which is color minus light and shadow. The value plan establishes a focal point and becomes a road map to the finish.

Enhance the Color
Try a limited palette of transparent colors. Have fun, keep it simple and exploit the color. Paint it more colorful than your photo. Remember that this is only a sketch; leave the details for the finished painting. For accents, I sometimes use a little opaque Cerulean Blue.

50

PALETTE

Antwerp Blue
Aureolin
Cerulean Blue
Hansa Yellow
Payne's Gray
Permanent Magenta
Permanent Rose
Quinacridone Red

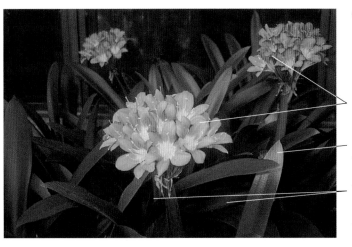

Colorless Photo

Flowers change in value but not color.

Glare from the light washes out the color.

There is no visible reflected color on the leaves, and therefore they are too dark.

Pour On the Color

This unusual flower has a great design; too bad the photo does not show enough color change. To correct this, I varied the color with more light and contrast. You can make a simple subject something great to look at by uplifting the color. Dream in Technicolor—that's the way I dream, too!

1 Paint the flowers with washes of Quinacridone Red, Hansa Yellow and Permanent Rose.

2 Paint the leaves next with washes of Antwerp Blue and Payne's Gray.

3 Add the stalks with a mix of Hansa Yellow and Cerulean Blue.

4 Paint the petal separations (the negative spaces) with Permanent Rose.

5 Orange (Aureolin plus Quinacridone Red) adds warmth to the leaves, and lavender (Quinacridone Red plus Antwerp Blue) adds shadows.

6 Add final dabs of Cerulean Blue around orange flowers for color tension. Add the darks with Permanent Magenta.

Embellish good research

It is rewarding to have good photos from which to work even though some changes will be made. You want to be inspired. What made you want to paint the subject in the first place? Find that answer and stay with it throughout the painting process. Make the subject better than it looks whether you are working from real life or photo research.

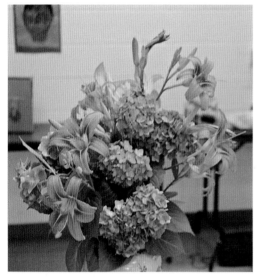

Good Reference Photo

This photo shows colorful flowers with soft lighting from the right side and overhead. It is worth pursuing. Let's try it.

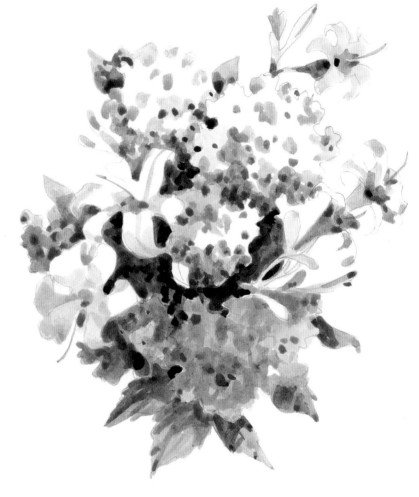

Value Study

Use India ink diluted with water for the various grays in your study. You can use watercolor should you prefer; however, ink washes work faster. To make a better composition, add more hydrangeas to the top of the sketch for balance. They are closest to the light source. The flowers at the bottom of the sketch are all in midtone. Add your darkest darks next to the lightest lights for contrast.

Compose and Edit

Try a contour line drawing. Eliminate needless items. Only put in what you need to tell the story.

Exploit Color

Do a light pencil sketch and have your value study nearby. Remember the lighting. Let's embellish the color by surrounding the yellow-orange lilies with rich purples and dark blue-greens to make them pop.

1 Paint light washes on top of the hydrangeas using Quinacridone Red, Permanent Magenta and a mixed lavender of Permanent Magenta and Cobalt Blue.

2 Paint light washes of Hansa Yellow and Quinacridone Red on the lilies. Working down the paper, make the colors pick up more values. Let it dry.

3 Add the warm leaves with a mix of Aureolin and Cerulean Blue.

4 Paint rich darks around the flowers to highlight them using a mixed green of Aureolin and French Ultramarine plus Permanent Magenta. Darken the value of the lower hydrangeas to push them under and away from the light. Think more and paint less as you near the finish.

PALETTE

Aureolin
Cerulean Blue
Cobalt Blue
French Ultramarine
Hansa Yellow
Permanent Magenta
Quinacridone Red

𝒯ip

When planning your composition and lighting, it is a good idea to paint one object of the subject. Consider doing several color sketches of small sections of your composition before you start your painting. It is a good test to see if your color, values and, most importantly, lighting are all working.

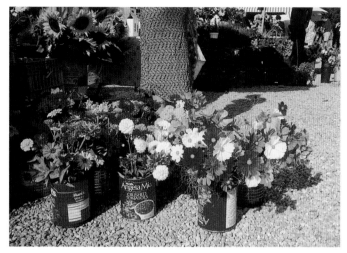

Reference Photo

This photo has rich colorful flowers arranged in unusual containers. What makes this subject matter exciting is the lighting contrast that provides rich darks around the flowers to project them.

Enhance the Composition

Here the ink contour lines clearly define the flower shapes. Edit the shapes as you go. Not everything you see needs to be put down on paper. Rearrange the containers and change their sizes. It is best to have one dominant shape and make the other shapes less important.

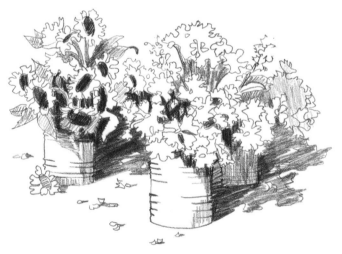

Dramatize Values

Use a 4B sketching pencil to give good, visible values. Select your darkest values and place them where your focal point is. This will help keep the shadow values from becoming more important than the focal point value.

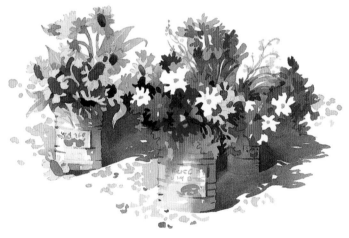

Enrich the Color

Use your full palette. Paint all flowers with clean, light washes, letting them run into the containers. When those are dry, paint the greens in light to mid-tone values. Make the all-important shadow shape with Brown Madder and French Ultramarine with a dab of Aureolin to gray the mix. Place the darkest values around the flowers in the focal point area.

Does your design pass the grid test?

A major tool for creating a strong design is the grid test. This test is simple to do and can help you identify a number of catastrophic design problems that could ruin your painting. Such problems include:

- a perfectly centered focal point
- poorly placed secondary elements that distract from the focal point or lead the viewer's eye out of the painting
- areas that have no activity and attract unwanted attention

Here's how to test your painting. For the grid test, you'll need a clear sheet of heavy acetate and a permanent ink pen.

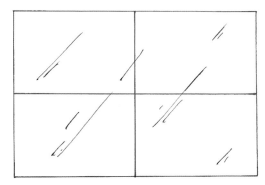

Make a Small Grid
Cut the acetate to fit your sketchbook. Mark centerlines from top to bottom and from left to right using the ink pen. This will create a grid of four quadrants. Tape this grid to the inside cover of your sketchbook to have ready for future use.

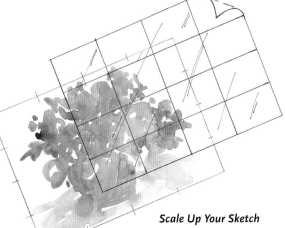

Place the Grid Over Your Sketch and Evaluate
Paint a small sketch, or select one you like from your sketchbook. Place the acetate grid over the sketch and look at each quadrant. Is there an area in which nothing is happening? Is the dominant shape too centralized? Is a badly placed secondary shape directing the eye off of the paper? Now that you see these problems, you can make changes. This is the value of the grid.

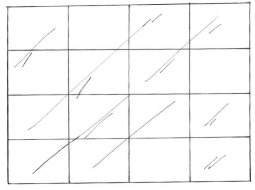

Make a Large Grid
Using a grid can also allow you to enlarge your design accurately. Cut a large sheet of acetate and place this over your drawing. This time, draw six lines—three equidistant vertical ones and three equidistant horizontal ones. I have made these grids for both half-sheet and full-sheet papers, my most commonly used sizes.

Scale Up Your Sketch
On a large piece of watercolor paper, lightly pencil the grid lines that are the same as those on the large acetate sheet. Lightly sketch your drawing, scaling up the proportions. Place the acetate grid over your drawing and look at each section to be sure that it follows your sketch.

*I*mprove a poor composition

Painting research springs from the artist's setups, photos, sketches and imagination. Whatever your research includes, the goal should be to improve the composition, light and color. In a classroom setting, it is not always easy to get the best view of a still life that has been set up in front of you. If you are painting on location, you might not always have the luxury of the best view, either. You have to look at what is directly in front of you and make it work.

Let's look at a few examples of how to rework what we see to make it better.

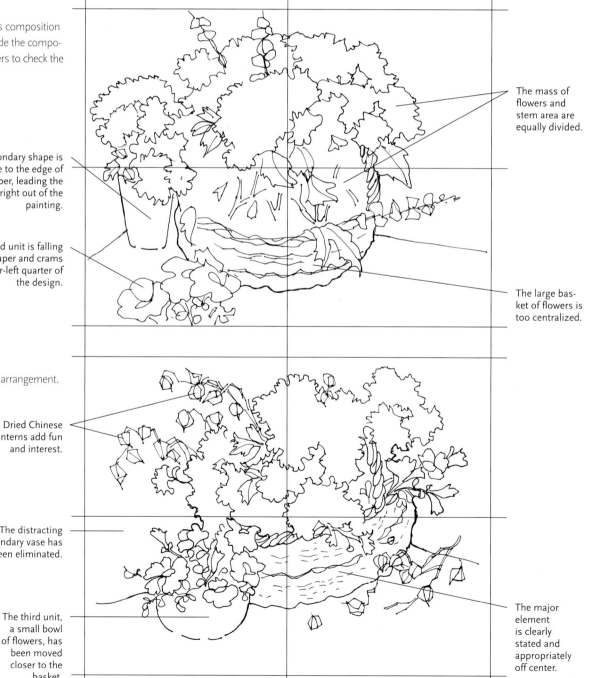

Poor Composition
Would you accept this composition and duplicate it? Divide the composition into four quarters to check the design.

This secondary shape is too close to the edge of the paper, leading the viewer right out of the painting.

The third unit is falling off the paper and crams the lower-left quarter of the design.

The mass of flowers and stem area are equally divided.

The large basket of flowers is too centralized.

Good Composition
This is a much better arrangement.

Dried Chinese lanterns add fun and interest.

The distracting secondary vase has been eliminated.

The third unit, a small bowl of flowers, has been moved closer to the basket.

The major element is clearly stated and appropriately off center.

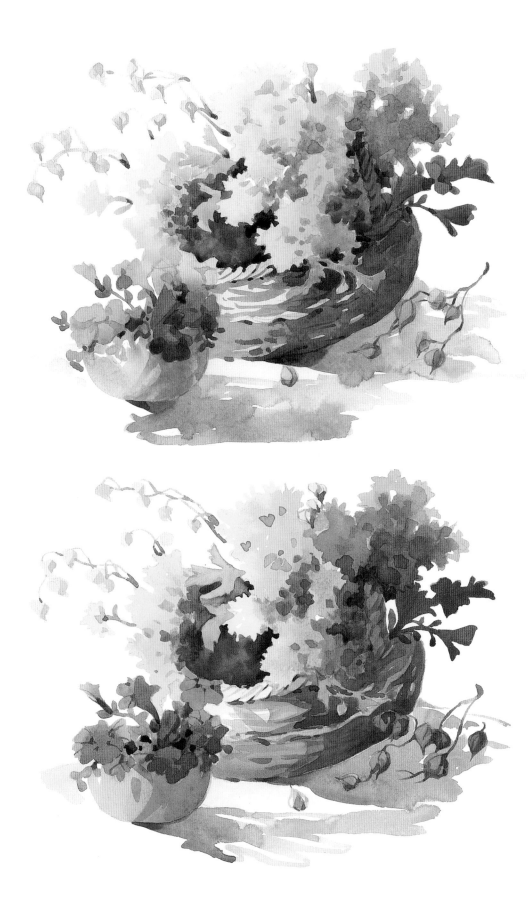

Color Sketch 1

I have resketched the improved composition. The light source is mid left of the subject, causing the values and shadows that you see. Yellows, oranges and browns were my choices for the dominant colors. I repeated blue-greens in the leaves and the small bowl. When finished, I realized the bowl color did not relate to the overall color scheme. Also, the brown basket did not enhance the flowers.

PALETTE

Aureolin
Brown Madder
Cerulean Blue
Cobalt Blue
Permanent Magenta
Quinacridone Red

Color Sketch 2

I used the same composition as before; however, this time I tried a different color approach. I used six of my favorite colors and tried to create better color harmony. The lavenders create a bridge from flowers to basket for unity. The bold color complements the yellow flowers and helps to simplify the whole design.

PALETTE

Cadmium Scarlet
Cobalt Blue
Hansa Yellow
Permanent Magenta
Permanent Rose
Quinacridone Red

57

The placement of the rocker draws attention away from the focal point—the hanging basket.

The ground flowers mingling with the basket flowers causes confusion.

To open up the design, the rocker was moved away from the basket.

To reduce confusion, some of the flowers were edited out.

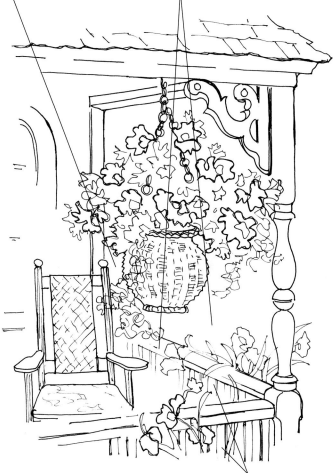

Poor Composition
This little porch and hanging basket have all the ingredients for a charming study. The ink sketch portrays exactly what I saw.

The railing has become too prominent.

Good Composition
I edited out the needless things and drew more attention to the hanging basket, which is the reason I wanted to paint this in the first place.

Less railing was included.

Tip

Sketching and painting on location is so valuable. Everything is waiting for you. Lighting is affected by the weather and time of day. To understand your subject matter, do several ink sketches of different views. Then do color and value studies until you are satisfied with the information. This discipline can help you get good results in a short time. With a few backup photos, you will be well armed to proceed to the final painting.

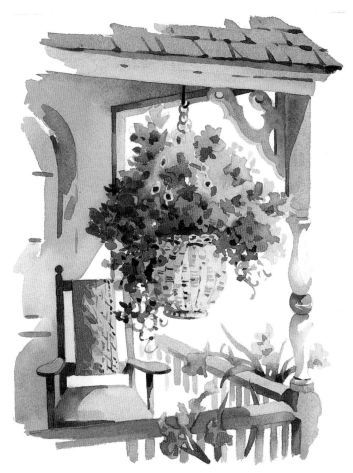

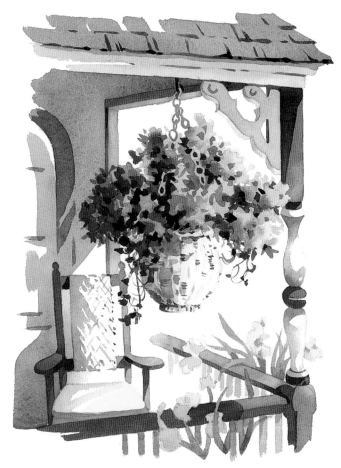

Color Sketch 1

Sunlight pours in on the right side of the subject. I depicted the resulting values and shadows by using warm and cool colors. The gray shadow is a mix of lavender and yellow. This sketch was painted with the actual colors just as I saw them. What do you think?

PALETTE

Aureolin
Cerulean Blue
Cobalt Blue
Permanent Magenta
Permanent Rose
Quinacridone Gold

Color Sketch 2

Okay, so I came up with a nice composition and used the original colors of the setting. Now I want to go for the feeling I experienced when looking at this scene: bright light, vivid colors and harmony. This is the time when my students will say, "Oh, you are making it up." I call it creating and giving an emotional response to what I saw. Pile on the color and enjoy the process.

PALETTE

Cadmium Scarlet
Cobalt Blue
Hansa Yellow
Permanent Magenta
Permanent Rose
Quinacridone Gold

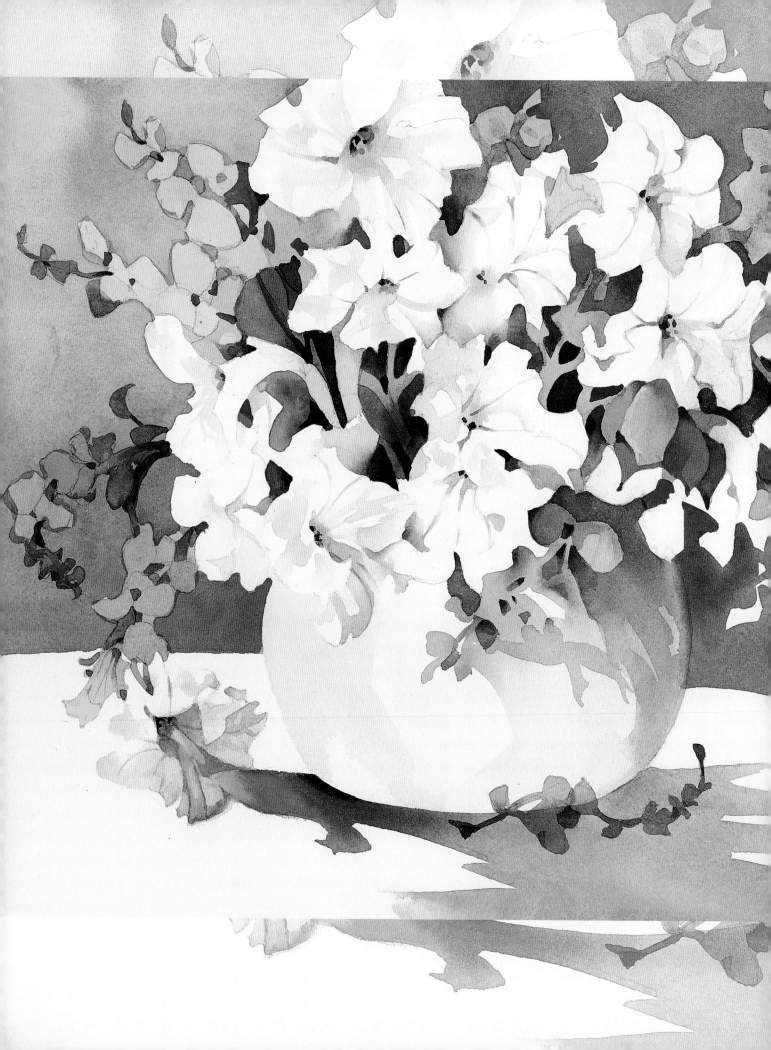

Exercises to Improve Your Art

In this chapter are exercises that are fun to do and informative, and hopefully the skills they help you develop will be carried over into your everyday painting. Discover the importance of making color connections that tie together the elements within your painting. Learn how to think in reverse by trying negative painting—seeing and painting the spaces around the shapes. The most neglected part of a composition is often the background. Practice two different approaches to backgrounds: painting it first and adding it at the end. These and other exercises, such as painting without a plan and creating mood with color sketches, are all geared toward stretching your skills to make you a better painter.

So, let your hair down and let's explore how to improve your art.

PERFECT COUPLE
15" × 22" (38cm × 56cm)

ℐeek special touches for your still life

I'm always searching for exciting elements to spice up my compositions. I raid my garden in late fall when the plants have finished blooming. I dry out the hydrangeas, Chinese lanterns and anything else I might find. Leaves, branches and berries are other possibilities. I look for something that has an interesting shape or color and will add that special touch to my painting.

Mother nature often provides some of the best designs, but silk flowers and other "fake" elements can come in handy. They provide great fillers during the winter months when live materials are not always available. Seek out the unique elements around you and practice making color sketches of items bearing different shapes, colors and textures.

Fruits and Vegetables
I frequently use fruits and vegetables in my compositions. With all of the variety, it's easy to select a shape and color that works best with your design. The pomegranate in this sketch almost resembles an oriental teapot. Its colors lend richness to a color scheme. If you cut one in half, the inside reveals another possibility for design.

Feathers
Feathers of all kinds present patterns we can use. These are wild turkey feathers that I collected on Martha's Vineyard. Since the turkeys nest up in the trees, their feathers can be found on the ground at the base of the trees. Place a few in your flower arrangement for a very unique touch.

Seed Pods
I was so fortunate to find these dried seed pods in a flower shop. They have a soft gray color and an unusual topknot. They come in all sizes, large and small; just pick the size you need for the scale of your painting. Their stems seem to dance as they bend in all directions.

Chinese Lanterns
I found these pure white Chinese lanterns growing wild in the back of my yard. The more familiar orange lanterns, which I have used as well, are the exact same shape. Their angular lines provide geometric elements to a design.

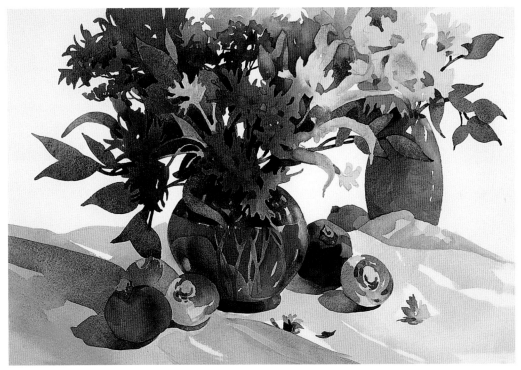

PALETTE

Aureolin
Cerulean Blue
Cobalt Blue
French Ultramarine
New Gamboge
Permanent Magenta
Permanent Rose
Quinacridone Gold
Quinacridone Red

Make the Shapes Count

I began this painting by laying in the light yellow flowers on the right. Next I added the fuchsia flowers and then the orange ones, which complete the connection of both units. When that was dry, I added all of the leaf shapes, which vary from warm, light mixed greens to cool, dark greens as they move away from the light source. The veggie and fruit shapes were allowed to touch both vases. They are the anchors that hold together and connect the composition. Lastly, I added the fabric colors and painted the two vases, being mindful of the lighting.

Then it was time to stop and check my plan. Did I create a dominant shape? The secondary shapes of the veggies and fruit are appropriately smaller. The smaller vase adds a third shape, making for an eye-pleasing uneven number. Final details include shadow shapes of warm and cool mixed grays. The fabric shadows are more subtle and only change where the lighting suggests. Look at the negative shapes inside the dominant flower shape as well as the white background shapes. Are they exciting and varied in size?

GLOWING ADORNMENTS
14" × 22" (36cm × 56cm)

Check Your Overall Design

When my painting was finished, I re-created its overall design with this small sketch. The black line outlines the dominant shape. The red line shows the secondary shape, and the green line reveals the smaller third shape. You might try this simple outline before you paint to ensure that your design is sound before you start.

Negative painting

This exercise is like painting in reverse. The objective is to plan a design and paint only the negative shapes. This exercise is not meant to result in a finished painting; it is merely a challenge that will make you think a little more about the negative areas in your work and not just the positive shapes.

Use transparent pigments for their clarity and glazing abilities. This process can also be used with different colorations as long as you use transparent colors. You could use cool analogous colors to create a quiet mood. Try other combinations to create different effects.

MATERIALS

Paper
Stretched 140-lb. (300gsm) cold-press, 15" x 22" (38cm x 56cm)

Brushes
Assorted rounds
2-inch (51mm) flat

Watercolors
Aureolin
Cobalt Blue
French Ultramarine
Quinacridone Red

Other
White tape
Tissues
HB pencil
Sketch paper
Tracing paper

Select a Simple Yet Exciting Still Life
You can work from this arrangement or select something from your personal photo collection. Consider using only one container of flowers to simplify the composition. My choice for this exercise is a basket that has flowers of different sizes and shapes. This will provide many opportunities for painting negative shapes. How many do you see? Think in reverse.

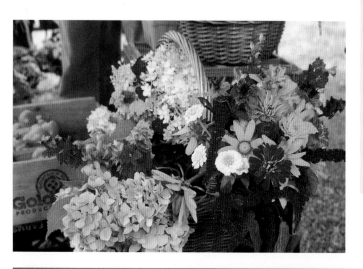

Prepping for the Underpainting
For this painting we'll begin by covering the paper with an overall wash of color (or underpainting). The actual wash takes only a few minutes to do. Preparation is the key to making it go smoothly. Put Aureolin, Cobalt Blue and Quinacridone Red in separate areas of your palette. Use one round brush for each color and add water to "activate" the color, creating three big puddles. Let the round brushes remain on the palette next to the puddles in case you have to remix.

1 Underpainting Part 1: Apply Yellow

Prop up the painting support a little at the top so that the washes to come will flow down the paper. Each wash should be light in value (approximately a 3 on the value scale). The entire underpainting (the next three steps) should take only about five minutes to complete.

Use a flat to apply clean water over the entire paper to dampen the surface. Use a tissue to wipe the edges of the paper as you go along. Using the same brush, apply Aureolin starting at the top right side and making one continuous stroke diagonally going off the paper. Do not break the stroke or go back into the wash; if you do it will look choppy or splotchy and won't blend properly. Notice the beading on the tape, which will have to be wiped off. Immediately move on to the next step before this step dries.

2 Underpainting Part 2: Add Red

The yellow wash covers about one third of the paper. While it is still wet, quickly add the Quinacridone Red, but use caution: the red could easily become too strong and overwhelm the underpainting. Limit the amount of red you apply, and keep using a top-to-bottom stroke. Once again, wipe all edges of the paper to prevent blooms or backruns from occurring. Immediately move on to the next step before this step dries.

3 Underpainting Part 3: Add Blue

While the red wash is still damp, continue by adding Cobalt Blue in the same manner as you did the other colors, only let this wash dry. Do not disturb the wash in any way by adding more strokes in an attempt to make corrections. Go with what you have. You should have a fine wash of transitional color that looks like it was airbrushed.

The order in which you have applied the colors suggests a warm side and a cool side, which will reflect the lighting of the scene.

4 Sketch the Subject

On your sketch paper make a light pencil study of the subject. Draw only the contours of each flower. This will prevent you from overdrawing the positive shapes. Now look within and around the subject. Sketch as many negative shapes as possible; there are many within the basket. If you do not have enough, then just add some. More is better in this case.

5 Transfer the Sketch

Enlarge your pencil sketch onto tracing paper to use for the transfer to your under-painted watercolor paper. Keep the paper clean and free of erasures, which could disturb the color underpainting. Keep the pencil line light, and do as accurate a drawing as possible. Remember not to get involved with the interiors of the positive shapes. When you draw the negative shapes, the positive shapes will appear.

6 Begin Adding Color to the Negative Shapes

The hardest part is over. It is time to investigate the negative shapes using the transparent primaries to paint them, following your drawing. You do not have to address the background area at this time. Paint only the negative shapes within the subject.

Starting at the right side, add color to the negative shapes; repeat the underpainting colors, which are warm in this area. Now paint the negative shapes in the center of the composition. Start with Quinacridone Red and then add French Ultramarine to the mix to produce purple. Remember to paint the negative shapes within the basket and its handle as well as those within the flowers and foliage. Keep the sizes of the shapes varied. The left side of the composition is cooler in the underpainting, so add blues (Cobalt and French Ultramarine), greens (French Ultramarine plus Aureolin) and lavenders (Cobalt Blue plus Quinacridone Red) for the negative shapes in this area.

7 Paint the Background and Shadows

Before doing the background, add a few eucalyptus branches to expand the design. Then paint the background using all four colors on your palette in darker values. You can do this several times if needed to increase the values to the desired darkness. Start on the right with warm tones, then add cool tones as you work your way across the paper.

The gray shadow on the tabletop is a mixture of Aureolin, Quinacridone Red and Cobalt Blue, in varying amounts. Mix a large batch of this gray in a separate cup. When you paint this wash, you can add small dabs of the three colors to change it a little in places. The recipe for this gray is something that you learn through trial and error. Keep the shadow wet and fluid. Add too much water and unwanted blooms may form; not enough water will make the wash look streaky.

8 Finish

Fill in some of the negative stem shapes within the cool section of the basket greens with a warm yellow-green (Aureolin plus French Ultramarine). When this dries, add Cobalt Blue, Quinacridone Red and purple (French Ultramarine plus Quinacridone Red) to "find" more stems. Using warmer colors, do the same in the smaller areas of greenery closest to the light source; use cooler colors as you move away from it. Separate the shadow shape from the background by adding a cool, rich purple (Cobalt Blue plus Quinacridone Red) to the background above the table on the left. Soften the wash as you move up the paper for a gradual transition. To do this, take a clean, damp brush and pick up the last bead of the wash while it is still wet, then pull it up the paper. This will prevent hard edges.

Take it one step further

Here are two negative painting examples that I took one step further by adding positive shapes, resulting in completed paintings.

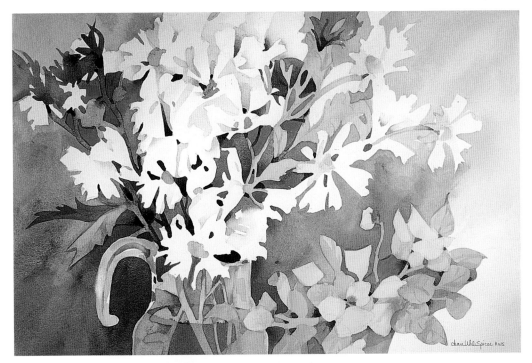

SCENTS TO CELEBRATE
15" × 22" (38cm × 56cm)

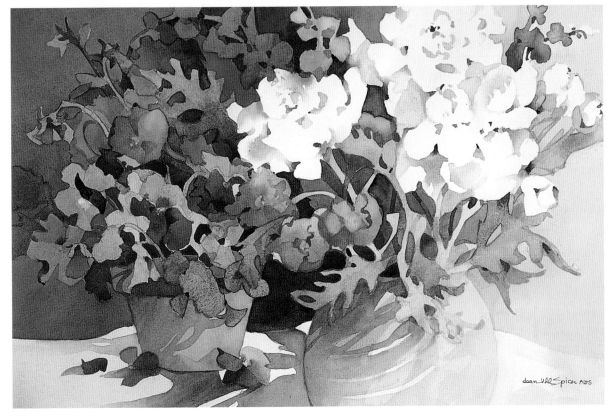

PEONIES
15" × 22" (38cm × 56cm)

Unify Your Painting With a Tie-In Color

When you have a setup of many different flowers, the array of colors in front of you can get very confusing. A variety of sizes and shapes will help further the design, but too many colors—more specifically, too many *unrelated* colors—can ruin a painting. You can reduce your color scheme to simple choices, and try to edit out any colors that might clash with that scheme, but there's another way to help ensure unified color: choosing a tie-in color.

A tie-in color connects the different areas of a painting and holds the design together. It is one general color that all the areas have in common. Without a tie-in color, individual areas of a painting may appear isolated and disconnected.

The following examples show some of the choices you can make for selecting a tie-in color.

Exercise 1

1 Paint a light wash of Permanent Rose for the pink flowers, with a little dab of Aureolin added in places. Apply Brown Madder for the flower centers.

2 Paint the green leaves with a mixture of Aureolin and Cobalt Blue.

3 Blue (a combination of Cerulean and Cobalt) is the tie-in color used for the background. Darker values of the background colors surround the flowers to push them forward.

 You might try several different colors for the background. Make sure your choice works with the overall color scheme.

PALETTE

Aureolin
Brown Madder
Cerulean Blue
Cobalt Blue
Permanent Rose

Exercise 2

1 Mix Aureolin and Quinacridone Red to paint the orange flowers.

2 Mix Aureolin and Cerulean Blue to paint the green leaves.

3 Mix Permanent Rose and French Ultramarine to paint the purple flowers.

4 Purple and orange are the key colors in this sketch. Orange is the tie-in color. Orange (Aureolin plus Quinacridone Red) was added to small stems, vases and flowers on the table to tie together all of the elements in the composition.

5 Paint the vase wet into wet using Brown Madder with Aureolin on the left side and French Ultramarine on the right.

6 To avoid isolating the green leaves, add green (Aureolin plus French Ultramarine) to the tabletop.

PALETTE

Aureolin
Brown Madder
Cerulean Blue
French Ultramarine
Permanent Rose
Quinacridone Red

Making Connections With Complementary Color
This painting illustrates how complements can successfully work together without competing for attention. Yellow is the dominant color, the star of the show. Its complementary color, purple, is the connection color, tying the flowers to each other and to the edges of the painting. The values are light around the perimeter of the elements, midtone on the vase and darker around the center of interest within the tulips.

ENDURING CLASSICS
15" × 22" (38cm × 56cm)

Using Gray to Connect Warm and Cool
This painting illustrates the use of warm and cool tones with gray as the tie-in color. I painted the warmer colors first on the flowers and leaves. Since I wanted the cooler colors to dominate the painting, I added grays to the darker leaves, purple flowers and seed pods. The grays connect the warm and cool colors en masse. They also connect the bowl, the fabric and the edges of the paper.

PALETTE OF COLORS
15" × 13" (38cm × 33cm)

Unite your design with color connections

This exercise will help you achieve continuity in your painting through the use of color connections. We will use a limited palette in which the majority of colors are transparent pigments, with the exception of two or three colors. Using the opaques sparingly and with a lot of water in the washes will help to prevent them from overtaking the transparents.

MATERIALS

Paper
Stretched 140-lb. (300gsm) cold-press, 11" x 15" (28cm x 38cm)

Brushes
No. 7 rounds

Watercolors
Aureolin
Brown Madder
Cerulean Blue
French Ultramarine
Lemon Yellow
New Gamboge
Permanent Magenta
Quinacridone Red

Other
Ink marker
HB pencil
Tracing paper

Reference Photo
This reference photo contains many warm colors. This could be the overall color scheme that will work for this exercise. There are too many flowers, so you need to lose some of them and reorganize the design. Think about the container. Do you like it?

Contour Drawing
Use an ink marker to draw a simple contour of the flowers and leaves that you want in your composition. Replace the tin can with a round vase that better suits the shapes of the flowers. Consider what may make a good focal point.

Value Study
Lay a piece of tracing paper over the ink contour drawing and lightly sketch the value plan in pencil. In this case, the light source is overhead. This naturally reveals a lot of darks next to the lightest lights, which will help define your focal point. The rest of the values will be midtones.

Color Study
The color scheme has been simplified. Yellows, pinks and oranges were placed on most of the flowers. Next the rust-colored flowers were added, and the container was added as well. The greens were added last, as they contain the vital dark and midtone values. You can already see the focal point. Make sure the shadow shapes are not darker than the darks within the focal point.

1 Start With Warm Tones

Make a pencil drawing first. Then, starting at the top, lay in the yellows (Aureolin and Lemon Yellow), pinks (variations of Quinacridone Red) and oranges (Aureolin plus Quinacridone Red) of the sweet peas. Flow these colors down into the yellow flowers, painted with Aureolin and Lemon Yellow. Let the yellow of the flowers on the right run into the nearby sweet peas. Add the ring of sweet peas around the top of the vase using the same colors.

Add a very light wash of Lemon Yellow and Quinacridone Red around the bottom of the vase, and paint the fallen flower. Paint the greens with a light, warm tone of Aureolin mixed with Cerulean Blue, minding the overhead light source. Add a few single flowers near the top of the arrangement using Quinacridone Red plus a little French Ultramarine to vary the value.

2 Apply the Tie-In Color

Mix a large batch of New Gamboge and Brown Madder for a lovely rust, which will be our tie-in color. It is a warm hue, so it goes well with your warm theme. Place some rust mums throughout the arrangement. Then, add the rust to the vase, varying the ratio of yellow to brown. Add a little rust to the tabletop. Add some Permanent Magenta to the rust-colored mums while they are still wet.

3 Develop the Values

Add the midtone greens with Aureolin and French Ultramarine. They should be concentrated in the middle and on the left side of the painting, where less light is found. Add the darks last with a mixture of Permanent Magenta, Brown Madder and French Ultramarine. This mixture should be darker than anything else and used sparingly. Place this color around the yellow flowers to establish the focal point.

Mix a gray wash using French Ultramarine, Permanent Magenta and a dab of Aureolin. Use this gray wash for the shadows on the vase underneath the flowers. Use this same gray for shadows on the dried green leaves. Paint the flower centers with dabs of Brown Madder and Permanent Magenta. Apply the darkest darks with a mixture of French Ultramarine, Brown Madder and a dab of Aureolin.

Evaluate your finished painting and see if you were able to avoid overpainting. The colors should all appear harmonious and like they belong.

The forgotten area: add a background

In a classroom situation, students can produce some really nice paintings. Students often ask, "What can I do for the background now that I have finished the painting?" You must think about the background from the beginning. It is an integral part of the composition. You may not need or want one, but make that decision at the right time and not at the end. In this demonstration, we'll add the background at the end, but we'll consider it before we lay any paint to paper.

MATERIALS

Paper
Stretched 140-lb. (300gsm) cold-press, 15" x 22" (38cm x 56cm)

Brushes
Large rounds
Small round

Watercolors
Aureolin
Brown Madder
Cerulean Blue
Cobalt Blue
French Ultramarine
New Gamboge
Permanent Rose
Quinacridone Gold
Quinacridone Red

Other
Ink marker
HB pencil

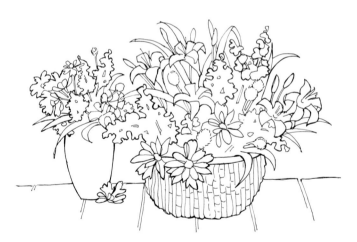

Reference Photo
This is an interesting floral arrangement, but the background in this photo should not be used. The background should be more interesting and relate to the subject. Consider the background as a shape of color or colors that will work with the rest of the composition.

Line Drawing
Rearrange things as needed when you make a preliminary line drawing. Here the containers were changed and the stones on the ground were edited out. Leave enough space around the flowers for the background, which should be well designed. Keep in mind that the overall background shape should not be larger than the subject matter.

Value Sketch
Determine a light source. The light was placed in front of the subject. Start to pencil in the midtones, which make up the background. As a general rule, if your subject is midtone to dark in value, then plan a lighter background. Paint a dark background if your subject is light in value. Add a few darks in the center of each bouquet and a few around the vase and basket.

Lilies

Aureolin + Quinacridone Red = mixed orange

Light leaves

Aureolin + Cerulean Blue = mixed green + Cobalt Blue

Daisies

New Gamboge thin-to-thick washes

Green inside the basket

Quinacridone Gold + French Ultramarine = cool green

Basket

Aureolin New Gamboge New Gamboge + Brown Madder

Pods

Cerulean Blue + Cobalt Blue = mixed blue

Lilacs

Permanent Rose + Cobalt Blue = mixed lavender + French Ultramarine

Background

Aureolin + Quinacridone Red Brown Madder + Cobalt Blue

Color Chart

This chart shows the main color combinations used for this demonstration. (Additional colors used for the background include New Gamboge and French Ultramarine.) All of the pigments are transparent with the exception of Cerulean Blue and New Gamboge, which are used in light washes.

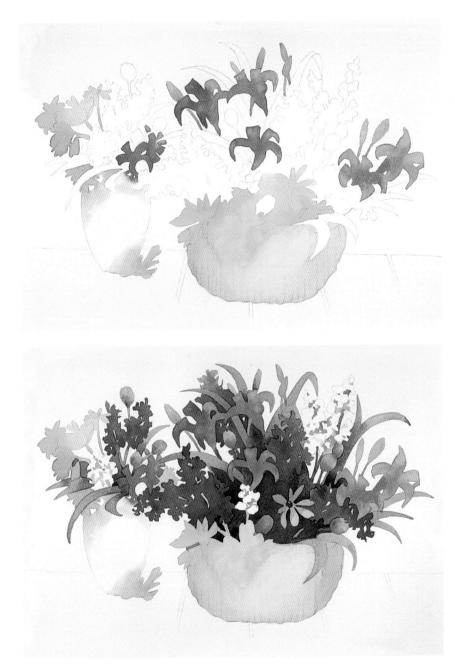

1 Begin the Flowers and Containers

Do a careful pencil drawing that you have enlarged from your ink study. Begin the lilies, daisies, basket and part of the vase with yellow and orange. Paint the lily buds with a green mixture made from Aureolin and Cerulean Blue. Notice how the oranges and yellows flow down through the flowers and into the white vase with softened edges. This connects the elements, creating unity.

2 Lay In the Remaining First Washes

Keep your colors fresh and bright for your first washes. Paint the lavender lilacs and the warm, light-green leaves. Save the white of the paper for the white flowers, and add dabs of Cobalt Blue here and there to suggest petals.

Paint the important darks inside the basket in a solid wash of cool green. This dark green will help you to judge the value of the background, which should not be darker than the focal point. Keep the interest within the floral arrangement.

It is not too late to make any additions you want that you may not have drawn, such as an extra lilac or a few extra leaves. Add some blue pods.

3 Build Up the Values

Now it is time to add the midtones. Be careful not to add too many, as you do not want to lose the freshness of the first wash. Add small amounts of darker values to the purple, orange and green areas.

Add more value to both sides of the basket, and add the table lines. Paint the small dots on the lilies with a mixed orange (Aureolin plus Quinacridone Red). Paint the flower centers with a little New Gamboge and Brown Madder. At this point most sections will be finished. Save any further details for later.

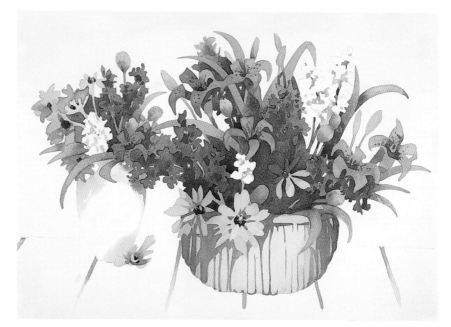

4 Apply the Darks and Paint the Background

Make a dark mixture by combining French Ultramarine and Brown Madder. Use this color to paint the negative shapes within the dark green area inside the basket to "find" the stems. The addition of this dark will also help to establish the focal point: the flowers nearest this darkest area of the composition. Repeat this dark to the right of the white vase as a connection to the focal point.

For the background, have large batches of mixed orange, Brown Madder, Cobalt Blue and Quinacridone Red ready on your palette, and a large round for each color. Starting on the left, apply Quinacridone Red, then Cobalt Blue, then Brown Madder. Work quickly, wet into wet, to avoid hard edges. Use fully loaded brushes and keep the background fluid, avoiding streaks. Repeat this combination going up the paper and across the top to the middle. Now change the colors by adding mixed orange. Continue across the top and come down the right side, applying Brown Madder, Cobalt Blue and mixed orange.

Use the small round to pull the wash into tight areas close to the flowers. While the wash is still damp, drop in dabs of New Gamboge for interest. For depth, add French Ultramarine to the wet wash on each side of the basket and behind the orange lilies on the right. The dried background should be a midtone of nicely fused colors.

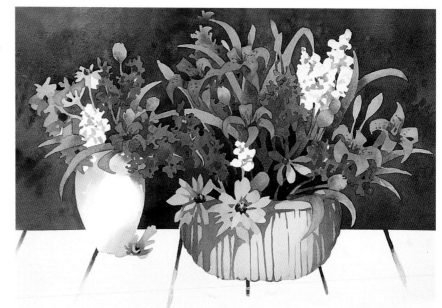

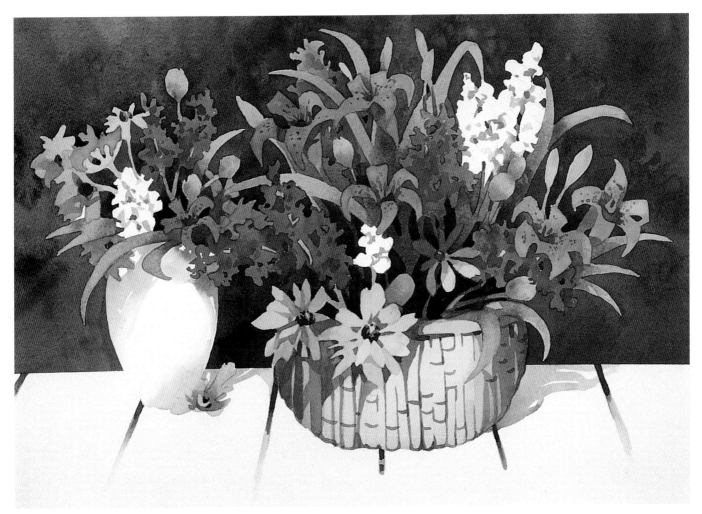

5 The Finale

Now it's time for final details. If your design and values work well, then only a few small details will be needed. Suggest a little basket weave. Add a few small darks to the white flowers to give them further form. Add two small shadow shapes to the right of the vase and the basket, and you're finished.

LILIES AND LILACS
15" × 22" (38cm × 56cm)

Try thinking backwards

You may want to try painting the background first. It's a little like thinking backwards; now the emphasis is placed on planning an area that is normally treated as an afterthought.

Using the Background to Develop Positive Shapes

After the drawing was completed, I started painting the background on the right, working around the white flower shapes. I darkened the values by adding more pigment as I continued around to the other side of the painting. While the background was still damp, I softened the edges of a few petals and allowed the background color to merge with their edges. As you can see, painting the background first was integral to creating the form of the flowers.

PEONIES
11" × 15" (28cm × 38cm)

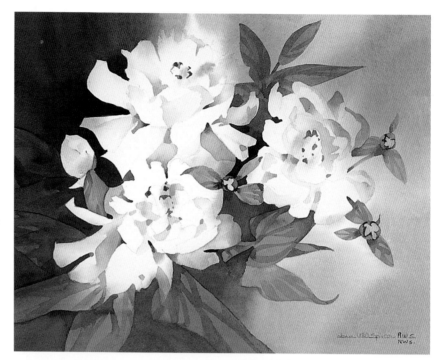

Thinking Green

Unlike the other background, this one had two steps. First, after I made a drawing, I painted the background with a light wash of yellow and green. Then, when the first wash was dry, I added green, blue and magenta across the background, painting around the bowl design with rich darks.

This painting is all about greens, here seen in the lemons, limes and apples. Green is the dominant color, hence the dark green background. The red strawberries provide the complementary color. Even though the background area is small, it is the very thing that makes the painting work.

FRUIT BOWL
15" × 22" (38cm × 56cm)

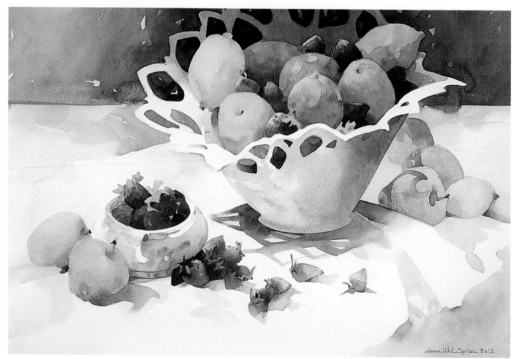

Get loose by painting without a plan

The exercises on the next two pages are just plain fun to do and will free you of your inhibitions. Forget everything you know and just rely on instinct. No planning is necessary. Instead of beginning with a drawing, you will be painting directly on the paper. Work on any paper you like and any size that is comfortable for you. The benefit of these color sketches is that they will help you see if your color and design has potential. Forget details and focus on capturing the essence of what is in front of you.

I have used Strathmore hot-pressed illustration board (heavy plate) for all of these sketches, which allows the paint to flow quickly. Each sketch took about forty-five minutes to do.

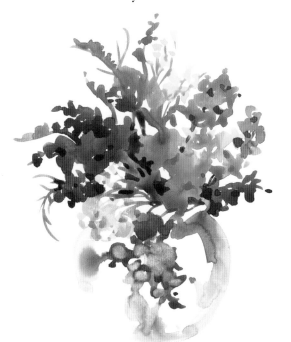

Exercise 1

1 Starting at the top, paint the lavender flowers (Permanent Rose plus Cerulean Blue). Let these colors merge wet into wet while adding Cobalt Blue to form other flowers.

2 Add yellow-greens (Aureolin plus Cerulean Blue) wet into wet.

3 Use a wet brush to pull down some of the purple on the right side and left sides to form the vase.

4 While everything is still wet, add Aureolin for the small flowers on the right. Allow this to run into the Permanent Rose, creating an orange mixture.

5 Add the darker flowers using a rich mixture of French Ultramarine and Permanent Rose. For the darkest darks, add more blue to the mix and a touch of Aureolin to gray it.

6 Paint the little orange flowers with a mix of Aureolin and Permanent Rose.

PALETTE

Aureolin
Cerulean Blue
Cobalt Blue
French Ultramarine
Permanent Rose

Exercise 2

1 Starting at the top, paint the flowers with Aureolin, Hansa Yellow and New Gamboge, letting them flow into one another.

2 Working into the wet yellows, add Quinacridone Red and allow it to integrate to create orange flowers.

3 Add red flowers with Permanent Rose, allowing the color to touch into the orange flowers. Drop a dab of Cerulean into the centers of these flowers while they are still damp.

4 Break up the reds with greens. Mix Aureolin and Cerulean Blue for light green leaves. Add more Cerulean plus Permanent Rose to this mixture for darker greens and squiggles around the flowers.

5 To form the vase shape, use a wet brush to tap into the red and green and allow it to flow down and form the shape.

6 Add final dark flower centers with a thick mix of Permanent Rose and Cerulean Blue.

PALETTE

Aureolin
Cerulean Blue
Hansa Yellow
New Gamboge
Permanent Rose
Quinacridone Red

Exercise 3

1 Paint all of the geraniums with Permanent Rose.

2 Mix Aureolin and Cerulean Blue to form the green, then add it right away to each leaf wet into wet. Let a little red from the damp flowers run into this mixture as well.

3 Add dabs of Cadmium Scarlet directly on top of the pink geraniums for a color lift.

4 Apply the small darks with dabs of Permanent Magenta.

PALETTE
Aureolin
Cadmium Scarlet
Cerulean Blue
Permanent Magenta
Permanent Rose

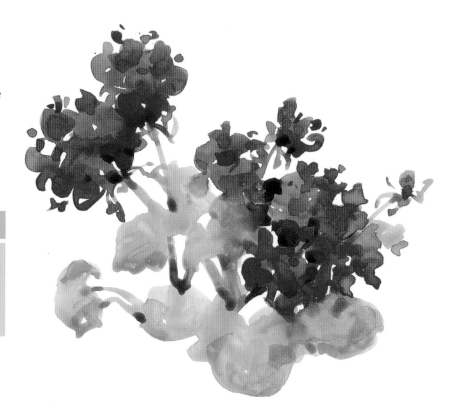

Exercise 4

1 Using Quinacridone Red and Permanent Magenta, paint all of the mums at once to create a dominant shape.

2 Add the lavender flowers with a mixture of Quinacridone Red and Cobalt Blue, allowing the color to touch parts of the damp mums.

3 Mix Aureolin and Cobalt Blue to make a cool green for the leaves, which help to extend the design.

4 When everything is dry, add Brown Madder for rich darks on top of the red mums and for their centers. Paint the negative dark shapes under the mums with a dark green mixed from Aureolin, Cobalt Blue and Brown Madder.

5 If the design looks too round, add extra mums around the edges.

PALETTE
Aureolin
Brown Madder
Cobalt Blue
Permanent Magenta
Quinacridone Red

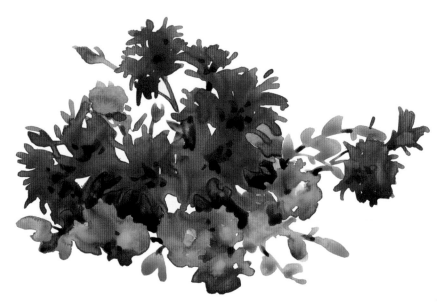

Set the mood with color sketches

These exercises deal with using color and texture to establish an overall mood for your work. Always aim for your paintings to say something more than just, "This is a flower painting."

Try using a slick surface so you can observe the different ways the paint flows and so you can practice creating textures on a smooth surface. Start with a light pencil drawing for each, and use a limited palette—four or five colors.

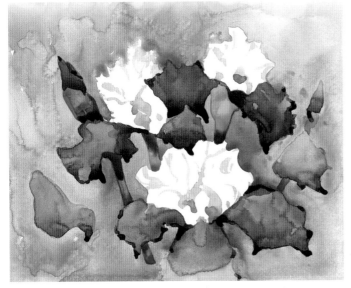

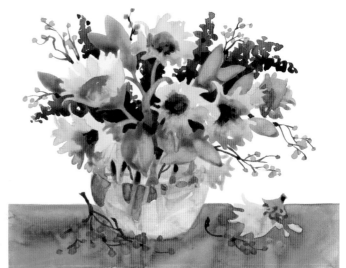

A Cool Mood

In this sketch, analogous colors work together for a cool mood.

1 Paint the background first with a Cobalt Blue wash, saving the white of the paper for the flowers. While it is still wet, drop clean water into the wash, creating texture. This will help to soften a few white petal edges as well.

2 When that is dry, paint the purple (Cobalt Blue plus Permanent Magenta) irises wet into wet.

3 While the irises are still damp, mix orange from Aureolin and Quinacridone Red and apply this to the top of the iris centers.

4 Mix Cobalt Blue and Aureolin for the cool green on the stems.

5 Add final touches of dark purple on the iris petals.

6 Mix Cerulean Blue and Quinacridone Red in a light value and add this to the white petals here and there to give them form.

PALETTE

Aureolin
Cerulean Blue
Cobalt Blue
Permanent Magenta
Quinacridone Red

An Autumnal Mood

In this sketch, try to convey the feeling of a cool, crisp day while mimicking the warm colors of autumn.

1 Using Aureolin plus New Gamboge and a few dabs of Quinacridone Red, paint the yellow sunflowers first, wet into wet. Add dabs of Brown Madder for their centers.

2 Mix French Ultramarine and New Gamboge for the cool green of the leaves.

3 Mix French Ultramarine and Brown Madder for the dark purple flowers.

4 Add more water to the same purple mixture to paint the bowl. Leave spaces for the stems, which should be painted next with a lighter version of the green used for the leaves.

5 Use Brown Madder and New Gamboge to paint the tabletop wet into wet. Leave space for a fallen flower, then paint it.

6 Add the berries (Quinacridone Red plus Aureolin) and branches (Brown Madder).

PALETTE

Aureolin
Brown Madder
French Ultramarine
New Gamboge
Quinacridone Red

Take cues from landscape scenes

When painting outdoors, we rely on the sun to determine the lighting.
Morning sun is soft, midday sun offers bright colors and strong contrasting
values, and evening light reveals cooler values and long shadows. When paint-
ing indoors, we can create the lighting we want, and I often keep in mind the
various atmospheric conditions that occur outdoors and how I might use
them in my floral paintings. For example:

- To convey a cool, rainy day, apply cool blues and grays. Drop water in wet
 washes to create rings of texture.
- Warm, sunny days should reflect good lighting and bright colors.
- For still lifes that evoke a wintry feel, consider white flowers, crisp edges
 and cold backgrounds.
- Twilight lends itself to oranges and blues in closely related low-key values.
 Add your own concepts to the list.

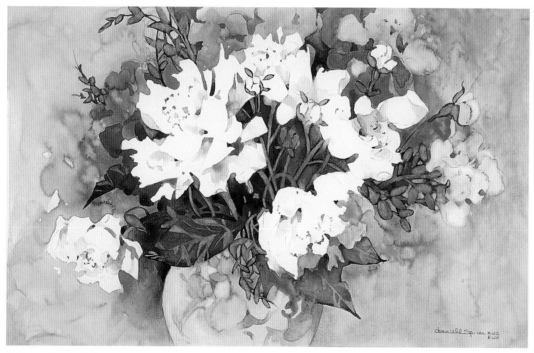

A Rainy-Day Painting

A cold, rainy day inspired this painting. This calls for cool colors, a limited palette and a little
texture. I didn't want to have too many contrasting values; most values are light or light
midtone. Just a few well-placed darks set the focal point.

 The most important element of this design was to carefully draw the pure white peonies
first. I then drew the other elements lightly in charcoal for easy erasure. The colors Cerulean
Blue, Cobalt Blue, French Ultramarine and Permanent Magenta contribute to the cool, rainy
mood. Water was dripped into the wet wash for texture. The darks are cool colors as well—
French Ultramarine, Permanent Magenta, and a green mixed from Aureolin, Cobalt Blue and
a touch of Brown Madder.

ENDURING CLASSICS
15" × 22" (38cm × 56cm)

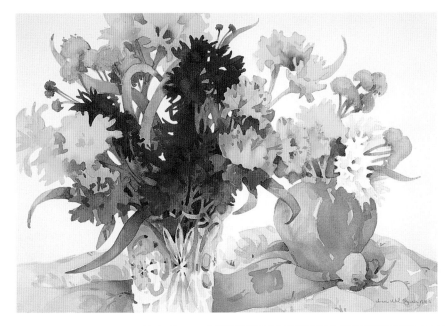

Spring Fling

This painting reflects the bright, sunny colors of spring. I wanted to create a happy and colorful mood. There are no earth tones or browns, and it was painted directly on a dry paper. The golden rule tells us that we should have an uneven number of elements in our compositions. I do that for the most part; however, here I have broken the rule with only two vases. The large dominant shape connects with the smaller vase, which seems to work in this case.

I also used a tie-in color to connect the whole painting. Yellow fills the dominant shape, flows into the smaller vase and eventually runs through the fabric. This also sets the warmth of the scene. I added the rich darks to declare the focal point. The dancing leaves give us a lift.

SPRING FIESTA
15" × 22" (38cm × 56cm)

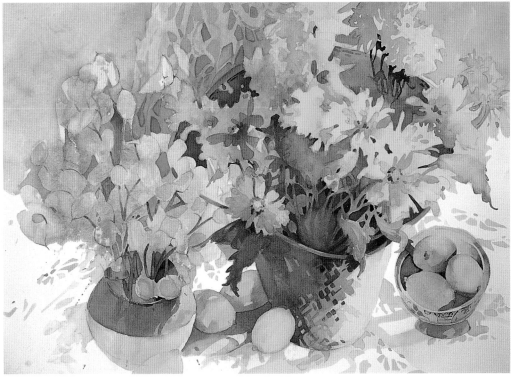

Pour On the Light

I wanted to create a warm, sunny mood for this painting. The challenge was keeping all of the elements warm and bright with a minimum of cool tones. Using a limited palette made this easier to do. The elements I chose—baskets, bowls, flowers and fruit—all had shades of yellow to reflect the mood. To offset this dominant color, I used complementary purples on the fabric, bowl, inside the basket and in the darker areas.

LEMON FLAVOR
17" × 24" (43cm × 61cm)

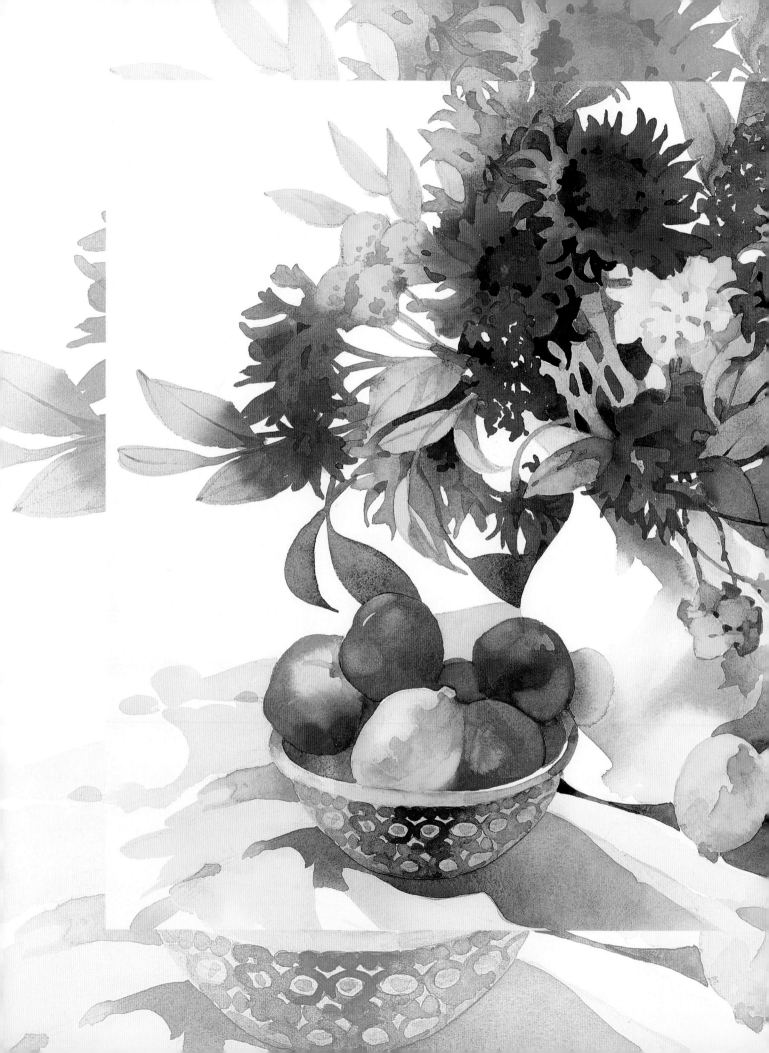

CHAPTER 5

Painting Flowers Step by Step

Use the following painting demonstrations to put into practice the lessons and theory you've learned in the previous chapters. The first demonstration focuses on the use of light and how to take advantage of shadow shapes. The second demonstration examines the choice of having a colorful background or not, a decision that I make early in the planning stage. See what my choice is for one particular scene and how I develop that area. The next two demonstrations allow you to practice working on hot-pressed surfaces for quick painting, good textures and great results. The remaining demonstrations show you how to handle a still life's secondary elements, such as fruit, crystal and lace. You'll also see how you can make silk and dried arrangements appear lifelike in your painting.

I hope all of the demonstrations will inspire you and encourage you to grow. Find your own strengths and develop that part of you. Have something to say that comes from you and is solely your own.

AUTUMN GOLD
18" × 24" (46cm × 61cm)

Use light and shadows

When you work with a strong source of light, try to take advantage of balancing the warm bright tones with the cool tones or shadow shapes that occur. Shadows can be fun to paint but should not override a composition; the flowers are the important issue.

Regardless of the research you work from, you can change or redesign the elements, keeping the lighting in mind. You can move the floodlights around, producing different shadows to paint.

MATERIALS

Paper
Stretched 140-lb. (300gsm) cold-press, 15" x 22" (38cm x 56cm)

Brushes
No. 7 and 14 rounds

Watercolors
Antwerp Blue
Aureolin
Brown Madder
Cadmium Scarlet
Cerulean Blue
Cobalt Blue
French Ultramarine
Hansa Yellow
New Gamboge
Permanent Rose
Quinacridone Red

Other
HB pencil
Kneaded eraser
Tracing paper

Reference Photo
The flowers and vases were placed on the floor. Placing a light overhead and behind the subject produced the shadows I wanted for the fabric. The warm highlights on the flowers are balanced by the cool shadow areas.

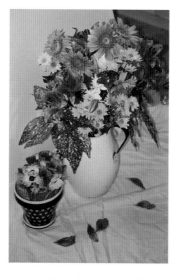

Preliminary Design Sketch
This sketch helps me to see the design and how it fills the paper. After designing the large pitcher of flowers and its partner on the left, I felt that the area on the right looked vacant. So, a third, smaller vase was added and connected into the large unit of flowers. Instead of incorporating the white flowers in the center of the pitcher's flower arrangement as in the photo, I replaced them with open spaces or general white shapes.

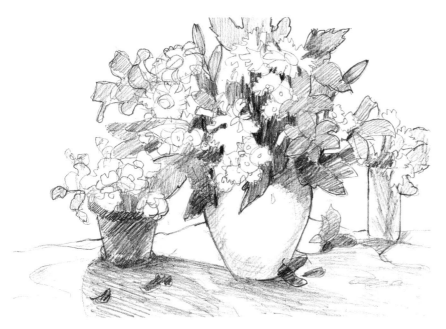

Value Study
The value study reflects the light
and shadows. The important factor
is the percentages of the values. In
this case, the midtones dominate,
the light values are fewer, and the
darks make up the smallest percent-
age.

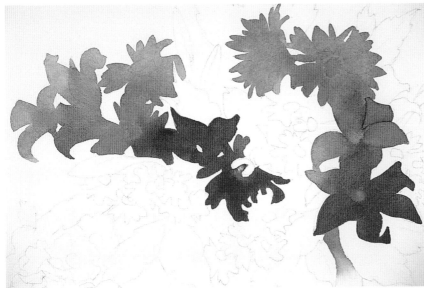

1 Make a Drawing and Apply the First Flower Washes

Enlarge the preliminary design sketch and trace it onto your stretched paper. Once you fill the paper you can see the design better, and if you need to correct anything, now is the time.

Mix a large amount of Cadmium Scarlet and Permanent Rose for the zinnias. Keep the mixture on the orange side to distinguish the zinnias from the pink lilies. Mix a large amount of Permanent Rose and Cobalt Blue for the lilies, which will be a little cool in tone. Using a brush for each color wash, start painting the flower grouping on the right wet into wet. Begin with the zinnias, then flow their color down and into the lilies. Use another brush for the cool wash and continue painting the lilies, allowing this wash to start running down into the white pitcher.

Repeat the same colors for the flowers on the left, flowing color wet into wet to integrate the unit. Keep their values light and less developed as they near the source of light. Add a little Cadmium Scarlet for the flower centers and edges.

2 Continue the Flowers and Leaves

When applying color, you shouldn't isolate any of the elements in the composition. Therefore the flowers in the small pot repeat the colors in the larger pitcher. Keep their values light. While the wash is still damp, add the brown centers using Brown Madder. For the blue-gray centers, apply dabs of Cobalt Blue wet into wet. Paint the small green leaves with a mixture of Antwerp Blue and Hansa Yellow, producing warm tones. Paint a first glaze of Hansa Yellow over the pot. Values and details will come later.

Start the daisies with Hansa Yellow, Aureolin and New Gamboge, flowing one yellow into another in light values. The New Gamboge helps to push the daisies back into the shadow areas, as it is a cooler yellow. Paint a first glaze of Aureolin over what will become the large green leaves. This underpainting will represent the speckles in the leaves when you add green on top.

3 Glaze the Fabric

Splash the three yellows in light washes on the fabric. Leave some white open areas to relate it to the background. There will be a cool shadow shape added later, so these initial warm colors become an important underpainting for future glazing.

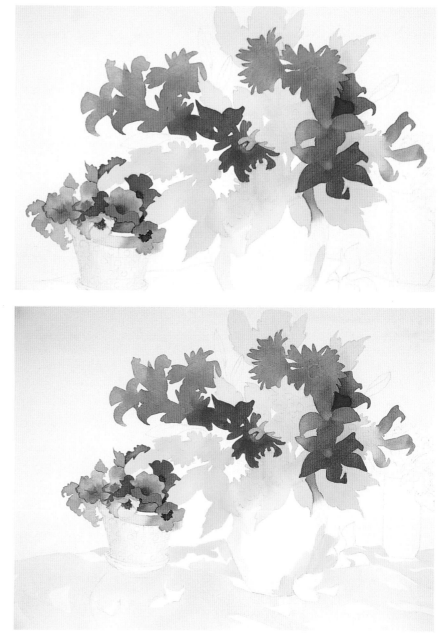

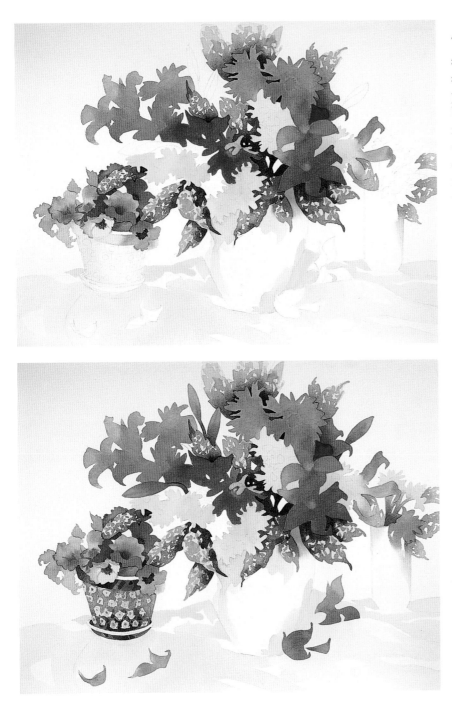

4 Create Speckled Leaves

Mix a green with French Ultramarine and New Gamboge. Keeping the value light, add it to the lighter leaves over the underpainting, forming a speckle pattern. Hold back a little to keep it from looking like the measles. Then add a little lavender (Quinacridone Red plus Cobalt Blue) to change value and add cool tones near the focal point—the flowers near the middle of the pitcher arrangement.

5 Run the Color Lap

At this point place a mat on top of the painting. It will help you to see how the design is coming together, as well as the color balance. Once you've checked this out, run a "color lap" all over the painting, adding color here or there.

On the small pot, glaze Cerulean Blue in a value that is lighter than in the reference photo. Leave open areas to reveal the design. Add purple to the mix using French Ultramarine and Quinacridone Red to relate it to the rest of the painting. Add light, warm greens to the sides of the pot to reflect the green leaf color and to connect it more to the rest of the painting. Complete the flower design on the pot with light, warm yellows and oranges. The design is there but it's not too important.

Paint just a few lily buds with light color and good shapes. Add a few lily petals on top of the fabric, keeping them subtle. Begin developing the flowers in the vase on the right.

This is the most important area of the entire composition. The lights are bright, the midtones are rich in color, and the darks to be added will establish the focal point.

6 Make Definitions

How much detail do you add? This is always an individual choice. I always say I like to stop just before I finish. I add only necessary things.

Add petal separations to the zinnias using darker versions of the first wash but being careful to maintain the light areas. Add a glaze of New Gamboge to quiet the daisies in shadow. For the daisy centers, start with a dab of New Gamboge, then mix a green from Cerulean Blue and Aureolin. Drop the mixed green right on top of the wet New Gamboge. When dry, a little separation of color will occur, which creates an orange ring around the green center.

Mix Quinacridone Red and Cobalt Blue in cool tones and glaze over the lilies on the right, increasing their value. These darks are important to establish, since they are within the focal area. Paint a glaze of Cobalt Blue over the green leaves in the shadow area near the focal point. Add small amounts of lavender (Quinacridone Red plus Cobalt Blue) to define just a few petals of the lilies on the left.

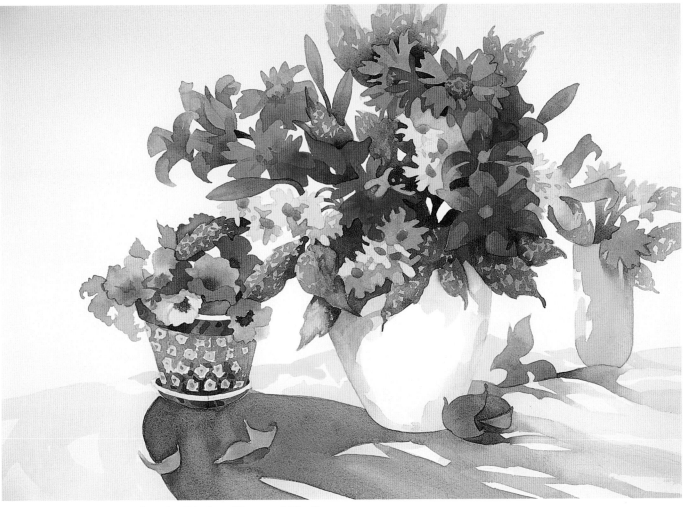

7 Develop the Pitcher, Vase and Shadows

For the shadows on the fabric, mix large puddles of Quinacridone Red, Cobalt Blue and Aureolin. Combining the red and blue creates the lavender, which is then grayed by adding the yellow. Use a no. 14 round fully loaded to cover a large area. Start at the base of the blue pot, and in long, continuous strokes, glaze the grays over the fabric, leaving a few open areas. Reload the brush and continue on the right side in a lighter value. Never back up into a stroke; always pull the color down and out. When this dries, you can better judge the value.

Use the same gray to paint a few shadow shapes on the white pitcher. These shadows define its form. Paint the vase on the right with a light mixture of Aureolin and a little Quinacridone Red. Add little dabs of Cerulean Blue in the bottom area of the flowers in the pitcher to repeat blue tones.

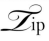

𝒯ip

Painting shadows is a matter of preparation and timing. First decide what colors will form the cool tones you need. (I usually pull them from the other colors of the painting.) You also need to select the correct value, which is perhaps the hardest thing to do. Painting fluidly produces the best results.

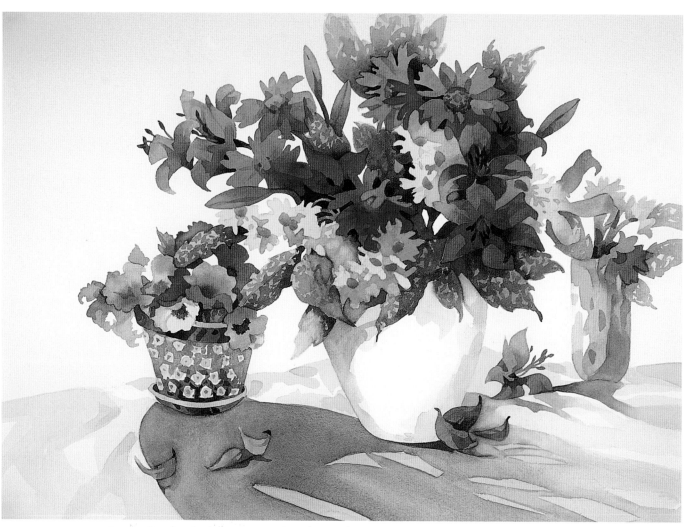

Tip

When finalizing a painting, place it on a vertical easel with a mat on top and then leave the studio. Later, you can check everything out with a fresh eye. Is the value plan working? Are the colors fresh and bright? Did you achieve what you wanted?

8 Final Details

Add Brown Madder stamens to the lilies. Add a glaze of yellow to the fabric's open areas, and give the orange vase another glaze to develop its form. Add more darks to the focal point to really punch up the contrast.

Now move on to a few other details. Glaze a light wash of Aureolin over the small flowers. Add a little French Ultramarine wet into wet to form stems. After the first wash dries, glaze these same colors over the leaves. Paint the flower petals on the fabric with Quinacridone Red and Cobalt Blue. Add a dab of Hansa Yellow to the tip of one petal in the light. Glaze the lily buds with a mixture of Permanent Rose and Aureolin, then add their stems and small lines with Aureolin and French Ultramarine. Apply a second glaze of Antwerp Blue for the shadows on the small leaves in the blue pot.

I had painted Cerulean Blue above the daisies in the lower left of the pitcher, but decided later that I wanted to lighten this area and consequently wiped it out. When this dried, I reglazed with Aureolin for a warmer look. The gray shadow on the fabric seemed a little too dark when it dried, so I dampened the area on the left and wiped out some of the gray. When that dried, I reglazed it with a light wash of orange (Aureolin plus Quinacridone Red) so that the fabric would not darken in value. I think it made a difference.

AROMA OF FLOWERS
15" × 22" (38cm × 56cm)

Add a background at the end

Whether to have a colored background or not is one of the first decisions to make when designing your compositions. This can alter your painting approach and greatly affect the results. The subject matter usually should dictate your choice. Starting with a soft glaze of colors over the entire sheet is one way to create a background from the beginning. Colors can also be added during the painting process.

When I want to dramatize white shapes or light colors, I often add a rich, colorful background at the end, as in the following demonstration. The value selected is the key, as always, to ensure success.

MATERIALS

Paper
Stretched 140-lb. (300gsm) cold-press, 15" x 22" (38cm x 56cm)

Brushes
No. 7, 8 and 10 rounds
1½-inch (38mm) flats

Watercolors
Antwerp Blue
Aureolin
Brown Madder
Cadmium Scarlet
Cerulean Blue
Cobalt Blue
French Ultramarine
Hansa Yellow
Permanent Rose
Quinacridone Gold
Quinacridone Red

Other
HB pencil
Kneaded eraser

Reference Photo
I often use silk flowers when seasons change and the choice of fresh flowers is limited. In this setup, the vases are a little isolated from each other and there is an equal ratio of warms and cools.

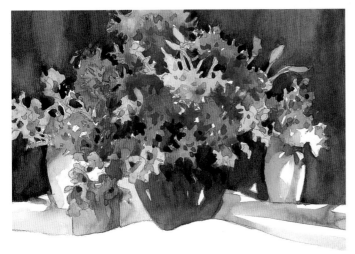

Color Study
I consider this 7" x 10" (18cm x 25cm) color study my road map. It's a good way to see if my planned colors are compatible. I chose an overall warm temperature for this painting. This painting will be about oranges and purples, which should be part of all the elements. Knowing that the background comes last, I want those colors to be included in this area. All of the flowers will be connected to each other.

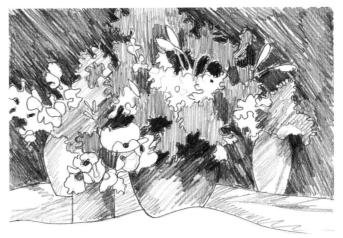

Value Study
This is where I establish the lighting, which is placed in front to showcase the flowers. The frontal lighting also provides light, warm values. The background will be a midtone to offset the contrasting flower values. The rich darks reinforce the focal point and will keep us centered on the main floral unit.

1 Make a Drawing and Begin the Flowers

Sketch a light drawing and then begin painting the mums wet into wet with Aureolin, orange (Aureolin plus Cadmium Scarlet) and Permanent Rose, allowing the washes to connect each flower in light values. Leave negative spaces for the addition of other flowers later and the definition of petal separations. Some of these white spaces will relate to the white fabric on which the vases will rest. Add a little water on your brush and pull the mum colors into the large vase, keeping the edges soft there.

2 Continue the Mums and Begin the Vase

Once the first wash is dry, add more mums, backing the color in to reshape petal edges from the first step. With a mixture of Hansa Yellow and Antwerp Blue, add a few green stems into the wet mums for blended connections.

Paint the little vase of flowers on the front left wet into wet using Aureolin, Cadmium Scarlet and Permanent Rose, connecting it to the large pitcher of flowers. Run the wash down to form the vase.

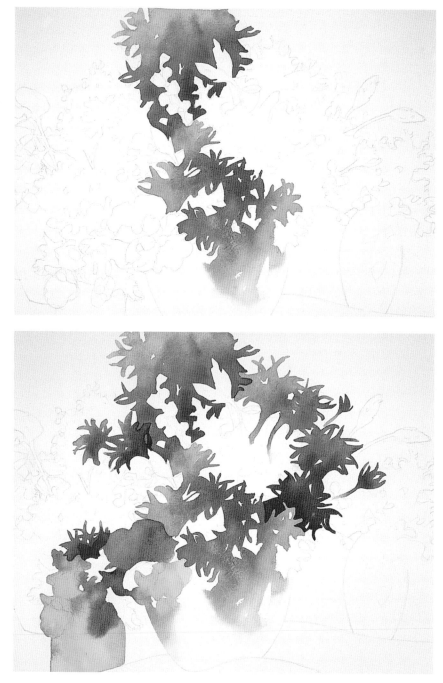

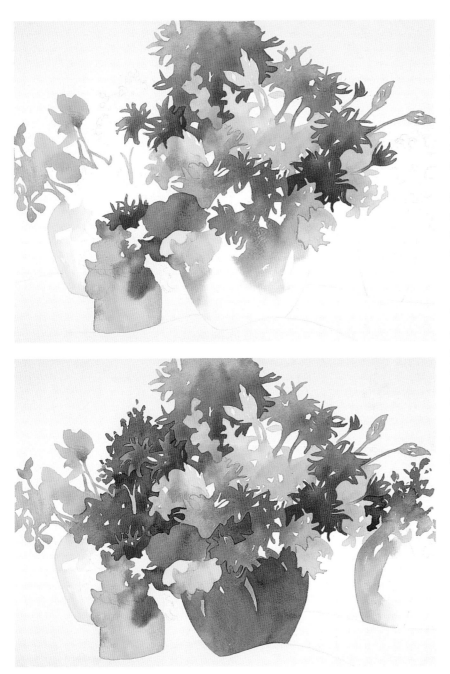

3 Tie the Painting Together With Yellow

Paint the little yellow flowers on the far left with Hansa Yellow to keep them bright. Mix the same yellow with Antwerp Blue to paint the green leaves, adding them next to the damp yellow. Apply a Hansa Yellow wash to form the far-left vase, letting the wash run down the paper.

Continue adding greens where needed, as individual shapes and in groupings. The extending straw branches painted with Aureolin and Cadmium Scarlet help to stretch the design as well as break into the background.

4 Finish Laying In the Main Elements

Finish the flowers by adding lavender (Cobalt Blue plus Quinacridone Red) and purple (Cobalt Blue plus Permanent Magenta) for the lilacs and the large vase. Apply a mixed orange (Aureolin plus Quinacridone Red) for the smaller vase on the right to finish laying in all of the main elements before you move on to the background.

5 Add the Background

There is a large area of background to cover, so mix large puddles of color and have flat brushes ready to apply the washes quickly. You'll use two separate glazes of transparent colors.

Mix a large puddle of French Ultramarine and another of Quinacridone Gold. Starting on the left side, use one flat for each color and apply them in an alternating manner as you move across the paper. Keep their values midtone and let them mix on the paper. Have a small brush available to cut in and around the flowers. While the wash is still wet, drag a little into the fabric for shadow shapes. Notice how the complementary colors combine for a gray wash. The colors of the background may look incorrect at this time; however, you'll apply another glaze once it's dry.

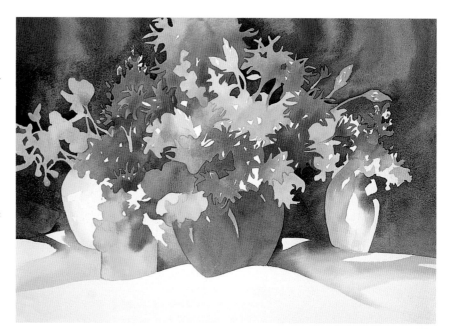

6 Add Values to the Flowers and Greenery

Increase the values of the mums near the focal point. Imply just a few petal separations. You don't want to lose the effect of the light source, so don't overdo it. Don't overdecorate the little orange flowers on the front left; they need only a few value changes.

Add more value to the leaves using Hansa Yellow plus each of the four blues (Antwerp, Cerulean, Cobalt and French Ultramarine) for color variation. These vibrant greens next to the complementary red-orange flowers create exciting color tension.

The lilacs need only a few value changes, with no extra details. Their darkest values should appear next to the orange mums, which helps to push the mums forward.

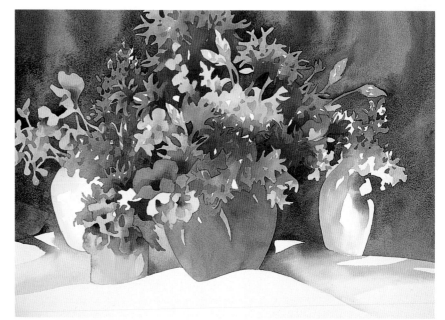

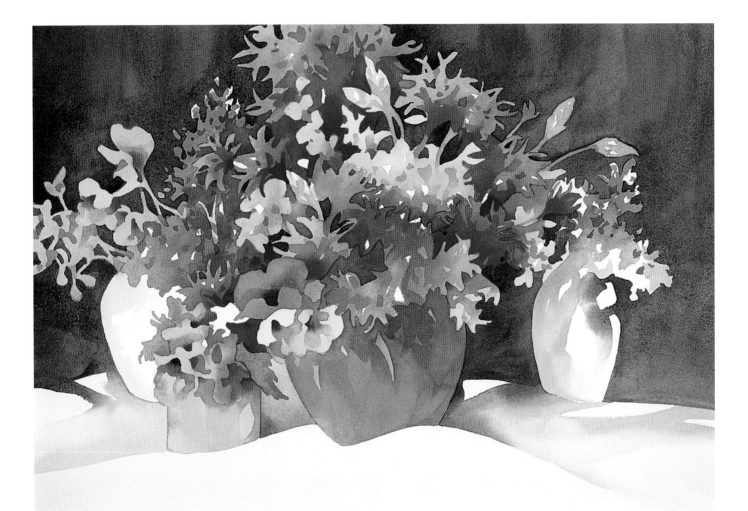

7 Apply a Second Glaze to the Background

Add a second glaze to the background only to alter the color, not change the value. Therefore, use a transparent color that will affect the overall coloration while still complementing the painting. Mix a large wash of Brown Madder. Using a flat, paint this color over the first background wash, being careful not to lift the underpainting. This shouldn't be a problem if the underpainting is dry. If you apply the Brown Madder wash over a wet underpainting, it will just make a muddy color.

When the Brown Madder dries you can see how it pulls together the blue-orange look, which now relates to the rest of the painting. Apply a little of the same glaze over the large vase to increase value and to vary the color.

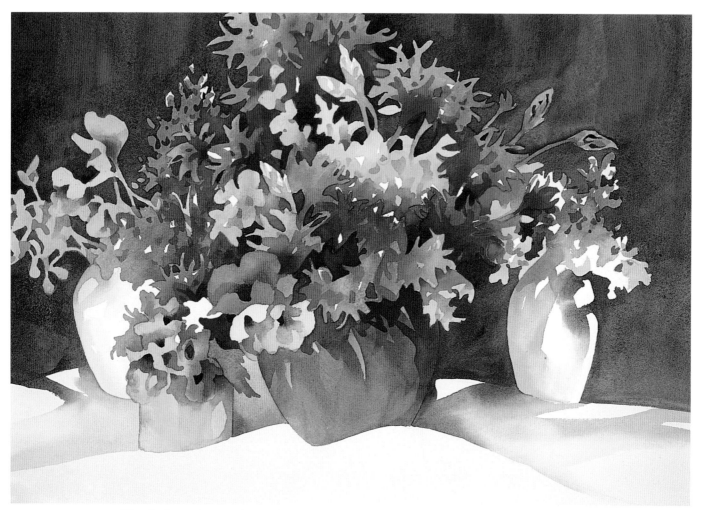

8 Check the Values and Finish

The large vase needs another value change. Darken the right side of the vase to equal the value of the background, thereby losing its edge. As a result, one side of the vase comes forward and the other recedes. Check the little white shapes that give the painting a little sparkle, filling in only a few with color. Add a few subtle shadows to the little vases, and you're finished.

LUMINOUS BOUQUET
15" × 22" (38cm × 56cm)

Tip

Finishing is the most difficult part of any painting. To simplify this stage, think of three things: Have I included enough but not too many details? Are the values correct? Have I created a center of interest? If you can answer yes to these questions, then it is time to put the brush down.

Paint a vignette

A vignette in painting means that your subject matter doesn't touch any edges of your paper. When choosing this type of design, it is important to think of the containment shape of your design. The design should fill most of the paper. The edges of your subject should all be different. Check to see if the negative background shapes formed by these edges are interesting.

This demonstration involves working quickly on a hot-pressed surface. You'll flood on the colors first then lift out the design. This is a good way to create continuity in your work.

MATERIALS

Surface
Strathmore four-ply bristol board,
15" x 22" (38cm x 56cm)

Brushes
No. 2 squirrel round
No. 6 and 7 rounds

Watercolors
Aureolin
Brown Madder
Cadmium Scarlet
Cerulean Blue
Cobalt Blue
French Ultramarine
Hansa Yellow
Permanent Magenta
Permanent Rose
Quinacridone Gold
Quinacridone Red

Other
HB charcoal pencil
Kneaded eraser
Cotton swabs
Tissues

Reference Photo
Here we see a beautiful display of flowers just waiting to be painted. The challenge here is the editing. Some things should be eliminated and others enhanced. Select an area that is important and build upon that.

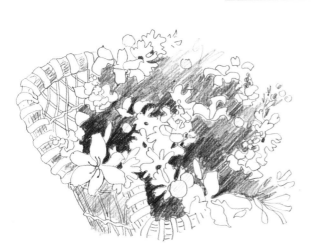

Value Study
This 7" x 10" (18cm x 25cm) sketch shows a three-value plan. The light is overhead, which highlights the flowers. Valuewise, the lights are in the majority; the darks are in the minority, surrounding the focal point; and the midtones are somewhere in between. I also decided that the flowers will sit on a wicker chair.

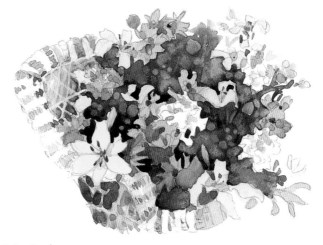

Color Study
This small sketch is the final look at the design. I edited out a lot of the busy areas by painting a midtone value in a solid shape. The lightest flowers were carefully placed around the entire shape so that the midtones would showcase them. This painting also takes advantage of complementary colors. Yellow and orange will create the warm tones, complemented by a cool, rich lavender.

1 Make a Drawing and Flood the Color

Enlarge the sketch using the charcoal pencil sparingly. Since the board is slick and soft, a lead pencil would indent the surface, causing ruts in a color wash. The charcoal, being softer, glides across the surface. When the drawing is completed, use a kneaded eraser to tap out some of the charcoal line to lighten the drawing.

Clip the surface to a board and place it flat on a table. Mix a large puddle each of Aureolin and Hansa Yellow to have them ready for the first wash. Starting at the top, use the no. 2 round to lay the colors on the surface; let them flood to do their mixing. Draw with the brush at the same time. Allow some of the wash to run into the wicker chair.

Using the same colors, flood the next wash down through the center front sections of daisies and lilies. Add pure Hansa Yellow for the large bright lily and run some of the wash into the wicker chair, adding a small amount of Aureolin plus Quinacridone Red to create orange. Add little dabs of Cerulean Blue for the flower centers.

2 Finish Laying In the Yellow Flowers

In finishing the right side of the painting with Hansa Yellow and orange (Aureolin with a touch of Quinacridone Red), draw with the brush in quick, single strokes. Flowers on the edge of the vignette should be attractive in shape. Use a little Hansa Yellow and Cerulean Blue to paint the lily buds.

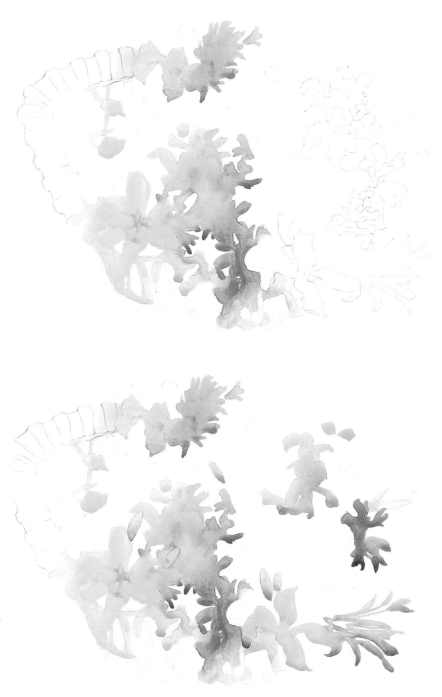

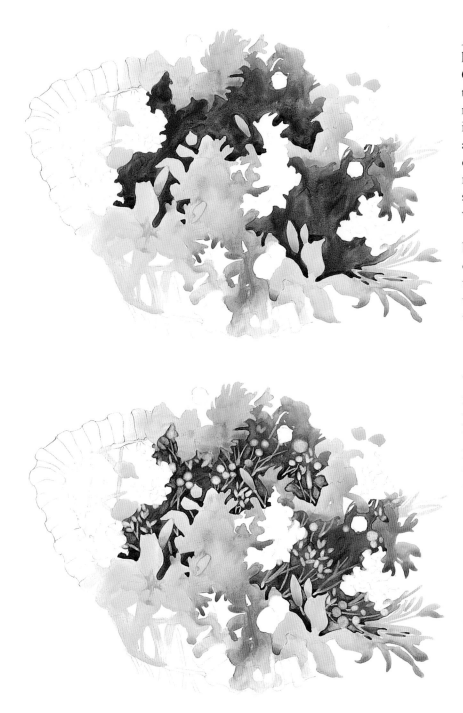

3 Bring On the Rich Values

To prepare for this important step, mix large puddles of Quinacridone Red and Cobalt Blue. Using the no. 2 round, start at the top and flood the two colors, letting them run into each other; the paper does the mixing. Have a small brush ready to cut in and around the yellow shapes. As the wash flows down, add French Ultramarine and Permanent Magenta. To this mixed purple, add small dabs of Quinacridone Gold, indicating where stems will be lifted out later.

This paper is sensitive; never push the wash back up the paper. Let it flow down to find its own path. When it is dry, you can see the textures that have formed. Paint this area darker than it should be, so you can lift out some of the color later on. You have to be bold.

4 Lift Out Flower and Detail Shapes

The quality of this paper for paint removal is excellent. To me, this is the fun part of the painting and the reason for using this paper. You can now play into the dark purple value and find new shapes. Sketch small flower shapes with charcoal and use cotton swabs to start lifting out color from each of these new shapes. Dampen the swabs slightly, and then lift out the little flower shapes, thistles and stems. Blot these lifted areas with a tissue. A small round brush can be used to lift out small lines. Soft tools for removal are the key.

This lifting removes so much paint that you almost regain the white paper. You'll add back a little color once the lifted areas are dry.

Tip

Cosmetic cotton swabs are good to use for paint lifting, as they have different-shaped tips: One end is oval, and the other is pointed, which is good for small areas. For paint removal, you can also use a damp brush or an old oil brush; use great care to not scrub the surface too hard.

5 Apply Color to the Lifted Areas

Fill in all of the additional colors at this point so you can see how the color balance is working. Don't let any one area appear isolated. Glaze the following colors over the lifted areas: (1) light Permanent Rose over the little flowers, (2) Cerulean Blue over the thistles, and (3) green (Aureolin plus a touch of French Ultramarine) over the stems. Extend a few thistles around the edges of the vignette for interest. Add dimension to the thistles within the yellow flowers in the front using Permanent Magenta.

As you can see, the purple mass of color now fits into the design. All of the lifting out and reglazing has pulled this section together while keeping it from being a congested, distracting area. Paint the pink snapdragons with Permanent Rose, and put a little color on the white flowers with wet-into-wet dabs of Aureolin, Cerulean Blue and Quinacridone Red.

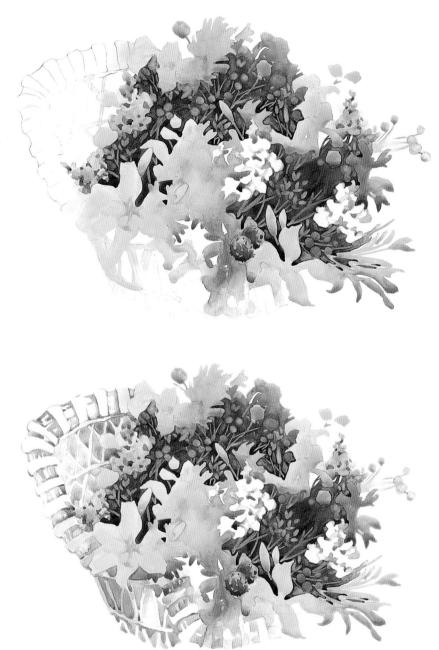

6 Paint the Wicker Chair

Don't overwork the chair; use light versions of the other colors in the painting to paint only the negative shapes in the wicker. Paint the shapes next to the lilies in a light yellow value. Create a cool lavender mixture of Cerulean Blue and Quinacridone Red for the rest of the negative shapes. Then add a little Quinacridone Gold to the lavender to gray the mix for applying under the arm of the chair in light values. The chair now supports the floral unit without disrupting the focal point.

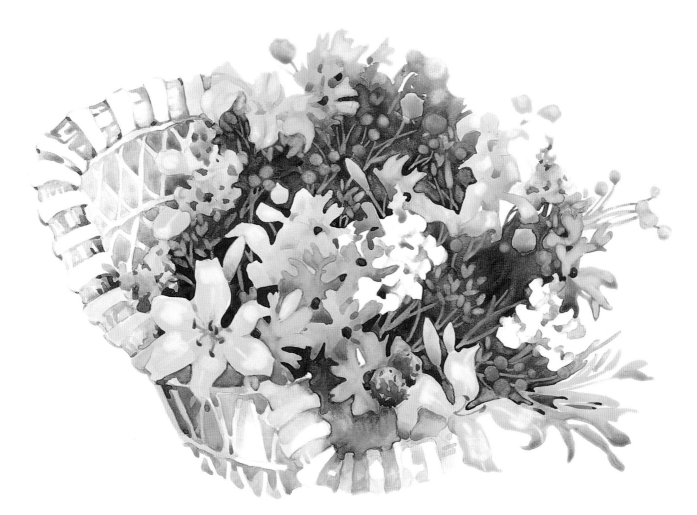

7 Nail Down the Focal Point

It is time to put the mat on and take a look before final details are added. Very little is needed. If the design and color work, it would be meaningless to add tons of detail. Merely adding detail will not enhance a bad composition.

Add stamens to the lilies using a mixture of Aureolin and Cerulean Blue, plus Brown Madder for the tips. Remove a little color from their petals with a cotton swab for a little variation in value. Do the same with the daisies, and when their lifted areas are dry, tint them with Hansa Yellow. Add the brown daisy buttons with Brown Madder as the final detail.

To set the focal point, add a rich purple mixture of French Ultramarine and Quinacridone Red plus a little Quinacridone Gold around the largest yellow lily and the flowers up front. Add a light green wash of Cerulean Blue and Aureolin, with a touch of Cadmium Scarlet to gray it, to the negative shapes in the lower part of the wicker, completing the painting.

VICTORIAN DAYS
15" × 22" (38cm × 56cm)

Let the surface work for you

When you want to loosen up, select a hot-pressed illustration board. The whiteness enhances the applied colors. If you rely on painting puddles of color rather than individual brushstrokes, the surface almost paints itself. Another advantage is that there is no need for stretching, as the board lies flat through the painting process.

Paint removal from this surface is easy, as the following demonstration will show. As when working on any hot-pressed surface, lifting out should be carefully planned, gently executed and not overdone. For artists who like direct painting and quick results, I recommend this surface.

MATERIALS

Surface
Strathmore heavy-plate illustration board, 15" x 22" (38cm x 56cm)

Brushes
No. 6, 7 and 8 rounds
No. 2 squirrel round

Watercolors
Aureolin
Brown Madder
Cadmium Scarlet
Cerulean Blue
Cobalt Blue
French Ultramarine
Hansa Yellow
Permanent Magenta
Permanent Rose
Quinacridone Red

Other
HB charcoal pencil
Kneaded eraser
Cotton swabs
Tissues

Arranging the Subject
This soft overhead lighting reveals highlights as well as subtle shadow shapes. Turn around the large bowl of flowers as you work out the composition to provide different views. Place the tulips as you see them.

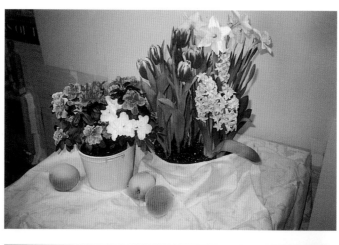

Another View
This photo reveals the best view of the daffodils once turned around. All of the flowers are important; however, keep in mind where you will place the focal point.

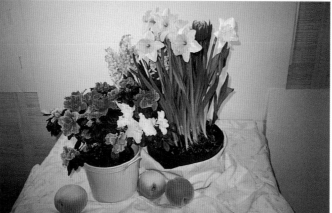

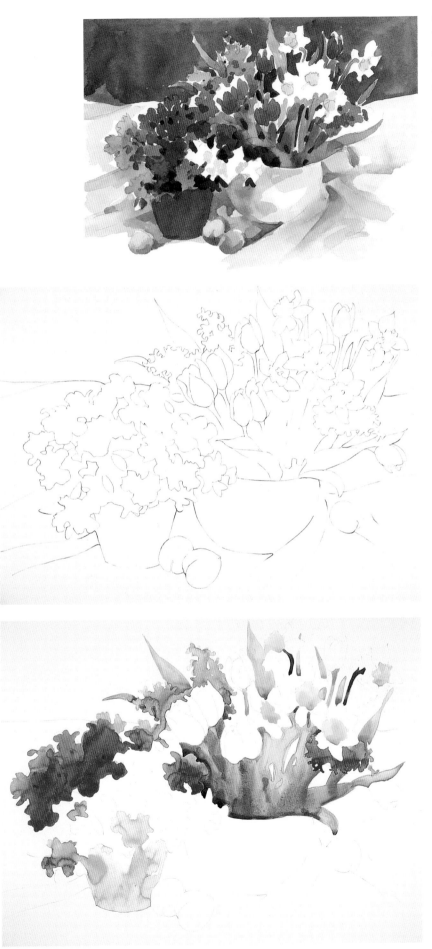

This 8" x 10" (20cm x 25cm) color sketch shows the chosen composition and, most importantly, the color coordination to aim for. The orange tulips are placed close to the pink azaleas, and the tulip on the far right repeats the orange. The pinks in the azaleas are repeated in the hyacinths. This also takes advantage of the white azalea color that relates to the white daffodils.

1 Make a Charcoal Drawing
Make a drawing with charcoal pencil so you won't indent the smooth paper. Use a contour line to identify all shapes, keeping the drawing clean with no erasures. (I made the line a little darker than usual here so that it would show up in the picture. Keep your line light; overdrawing would deposit too much charcoal and affect the washes.)

2 Begin the Reds and Greens
Keeping the board flat, use a no. 2 round to flood Permanent Rose and Quinacridone Red wet into wet over the pink azaleas. Add dabs of Cadmium Scarlet and Permanent Magenta, wet into wet. Let the paint mix and run where it wants to go. This also creates water blossoms, or backruns, in which the paint runs back into previously applied color. Sometimes this effect is undesired, but not this time. While the wash is still wet, drop in dabs of orange to vary the color. Paint a light Permanent Rose wash over the little bucket. Paint the hyacinths with a mixture of Permanent Rose and Cobalt Blue.

Mix a warm green from Aureolin and French Ultramarine and flood this over the large stems and leaves. While this is still wet, drop in Hansa Yellow for warmth and highlights. Add small dabs of Aureolin and Brown Madder for color and value change. Some lifting out will come later, once this dries.

107

3 Paint the Smaller Group of Greens

Paint the smaller batch of greens with a cool, dark mixture of Aureolin and French Ultramarine. Add dabs of Permanent Magenta, Cerulean Blue and Brown Madder for interest. Again, let the puddles flow naturally into one wash. Use a no. 7 round to cut the wash in and around the flowers. Use an additional smaller brush to paint the outer leaf edges.

4 Unite With Color

Flood Hansa Yellow and Permanent Rose for the fabric, starting in back of the subject. As you move toward the foreground, add Permanent Rose and Cobalt Blue to suggest early shadows. Allow some of the fabric color to go over the large bowl. Leave some of the white paper open to relate these areas to the other whites in the composition.

The tulips are a combination of yellow and reddish orange. Paint Cadmium Scarlet first, and then drop in Hansa Yellow wet into wet. To darken a couple of tulips, add Permanent Magenta into the wet wash. It should take just a short time to paint them, and they are most likely finished at this stage.

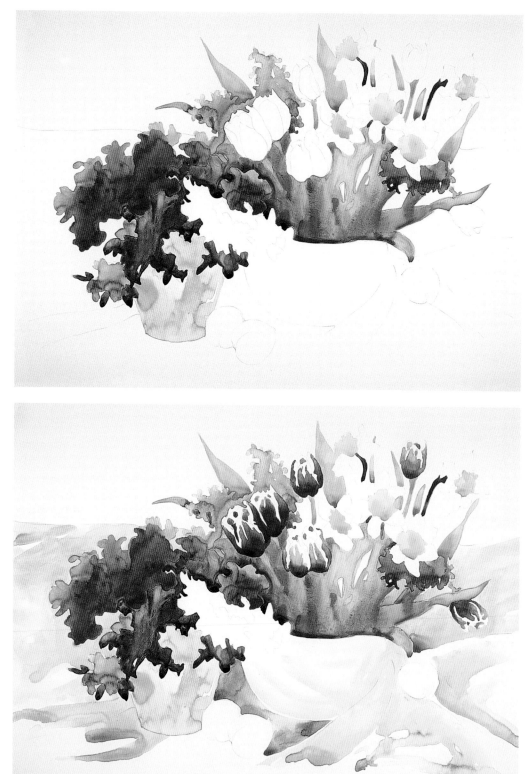

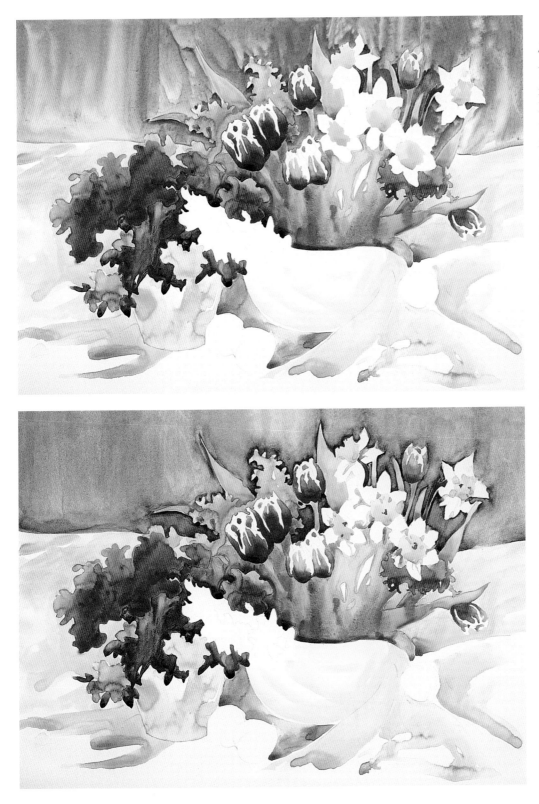

5 Paint a Dark Wash for the Background

To make a light lavender background, begin by flooding French Ultramarine and Permanent Magenta over the background shape with a no. 2 round. Make it darker and bluer than it should be, even though it will at first appear incorrect and incompatible with the rest of the painting. You will soften and lift out this wash in the next step, so you need enough value to start with. This procedure helps to give depth and solidity to the work.

6 Work the Background

When the background has dried, use a large, damp brush and lift out some of the color to lighten the area. This paper makes it so easy to do. Let some of the dark blue remain around the floral unit to project it forward. When this dries, apply a large wash of Permanent Rose over the entire background. See how the background now relates to the painting without becoming too important?

Soften a few daffodil edges with a damp brush and let the background color bleed into them a little. Complete the daffodils by adding a few shadow shapes with Cobalt Blue and a touch of Aureolin while retaining as much white as possible. When the centers of the daffodils are dry, add a touch of Cadmium Scarlet and Brown Madder.

7 Paint the Peaches, Bowls and Fabric

Paint all of the following very quickly, with wet-into-wet washes.

Keep the peaches simple by using Aureolin and Quinacridone Red in a single wash to cover them.

Glaze a mixed green of Aureolin and Cobalt Blue over the large bowl. Glaze the smaller bucket with Cobalt Blue and Permanent Magenta in a quick, single wash. Don't add anything further at this point, as details will be added later.

Lift out a few lights here and there on the fabric with a damp brush. Paint the shadows around the bowl using Cobalt Blue, Permanent Magenta and Cerulean Blue. Keep the fabric a simple statement.

8 Lift Out Color

Use damp cotton swabs to lift out color on the small leaves and stems around the azaleas. This will lighten and give dimension to the area, and when the lifted areas are dry, they can be glazed with a warm color. Use tissues to blot the lifted areas. Repeat this technique for tulip stems and a few of the leaves as well. Paint lifts so well from this surface that it almost returns to pure white.

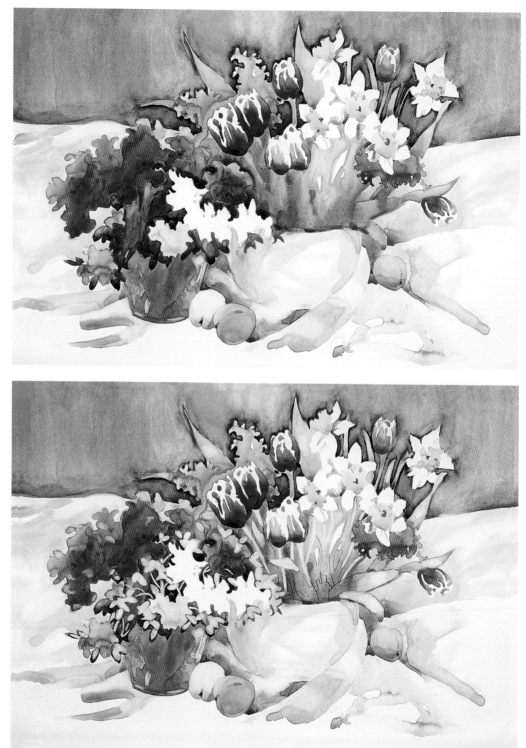

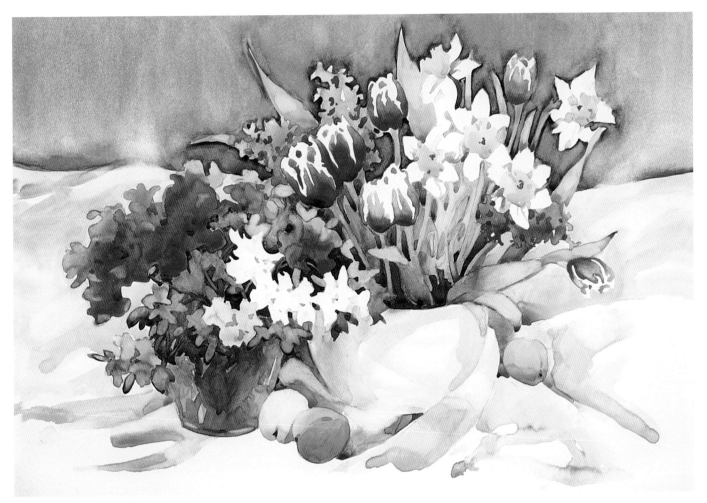

9 Final Details

Let's add final glazes, values and details.

For the azaleas, glaze with a mixture of Aureolin and Quinacridone Red the leaves that were lifted out. Add Brown Madder to the stems. To highlight the daffodil stems, glaze them with Hansa Yellow for warm tones. Glaze the tulip stems with light orange (Aureolin plus Quinacridone Red).

Add more purple (Quinacridone Red plus Permanent Magenta) to the small bucket to separate it from the background. Add the darkest values inside the large bowl using a mixture of Brown Madder, French Ultramarine and Permanent Magenta. Repeat this color under the white azaleas. This creates the focal point and ties the painting together.

Glaze a wash of Cobalt Blue over the fabric to the left of the large bowl. Add Cerulean Blue and Permanent Magenta to the fabric on the right.

This painting is all about complementary colors: purples and yellows with oranges. The color looks rich, as it was applied in flowing washes with no excessive mixing or additions. The whiteness of the board gives the colors "bounce."

ESSENCE OF SPRING
15" × 22" (38cm × 56cm)

Arrange the elements of a still life

It has been said that composing a musical piece is not very different from composing a painting. They both require the arrangement of highs and lows, loud and soft, foreground and background, and so on. It is up to you, the artist, to arrange the notes or elements in a way that pleases your audience.

This demonstration involves composing with roses, lace, fruit and a crystal vase. There will be one focal point accompanied by various other shapes and forms that should entertain your audience without taking away from the main center of interest. Final details will be carefully selected and placed only where they will enhance the focal point. Let's make music!

MATERIALS

Paper
Stretched 140-lb. (300gsm) cold-press, 17" x 23" (43cm x 58cm)

Brushes
No. 7, 8, 10 and 12 rounds

Watercolors
Aureolin
Brown Madder
Cadmium Scarlet
Cerulean Blue
Cobalt Blue
French Ultramarine
Hansa Yellow
New Gamboge
Permanent Magenta
Permanent Rose
Quinacridone Gold
Quinacridone Red

Other
HB pencil
Kneaded eraser
Tissues

Reference Photo
I took many photos of this still life to see it from all sides. The natural sunlight that poured through a window produced interesting light and shadows. I particularly like the shadow on the lace and will take advantage of that.

The Plan
This still life is embellished with persimmons, cherries and blue delphiniums. This all-important color sketch gives you a first try of selecting color balance, light and shadow placement. Most importantly, it will be a guide for how much detail to keep or lose, especially in the lace cloth.

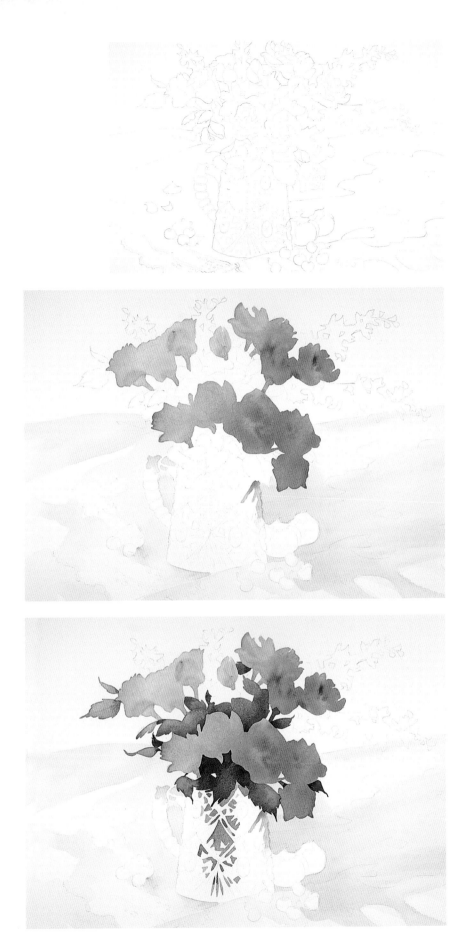

1 Make a Drawing

Draw the roses and crystal vase—the dominant shape—first to make sure that they sit correctly in the picture area. Place the fruit around the vase to add color to that area. Only lightly suggest the lace. The large, cool shadow cast by the vase will add interest and drama to the finished painting.

2 Begin With the Roses

Tap out some of the darkened pencil line with a kneaded eraser. To capture the delicacy of the roses, use a large brush with lots of water for the first wash of Permanent Rose, Quinacridone Red and Aureolin. Since the light source is strong on the left and overhead, darken the values by adding more pigment and less water as you paint the roses on the right side. Add a small pink-and-orange wash to the right side of the vase as a color connection that will be more fully developed later. While the roses are still damp, paint their stems with Hansa Yellow and Cerulean Blue wet into wet for a soft connection that looks more natural.

Glaze a light wash of red and yellow over the lace, leaving a few white areas. This wash identifies the fabric shape and repeats the rose colors down and around the composition. Try to establish the warm tones first as they can so quickly be lost and are much more difficult to add later.

3 Paint the Leaves and Start the Vase

Paint the green leaves around the roses wet into wet with a mixed green made from Quinacridone Gold and Cerulean Blue. Use a small, pointed brush to push the wash to form the leaf edges. Before the wash dries, add dabs of Hansa Yellow for highlights, Cerulean Blue for color variance and Permanent Magenta for darker values. Apply the same green used for the leaves to the vase to suggest stems and a little of the crystal vase pattern.

4 Paint the Cool Tones

Use a light wash of Cobalt Blue to paint the light shadow shapes that describe the fabric folds. This color also surrounds the vase to define its shape. Also add Cobalt Blue to the top of the vase for the shadows. Add a touch of Quinacridone Red to the blue wash and paint over the large shadow shape to the right of the vase to further define its shape with a first coating of color.

Paint the delphiniums next with a mixture of Cobalt Blue and Permanent Rose for a basic lavender. Paint quickly, letting your brush draw the petal shapes wet into wet. While the wash is still damp, drop in Cerulean Blue, Permanent Magenta and French Ultramarine for color variation. Add a little green (Aureolin plus French Ultramarine) for the stems here and there.

5 Add the Secondary Elements

For the persimmons, paint the first wash with Hansa Yellow, Quinacridone Red and New Gamboge, leaving the stems colorless. Paint the cherries in single wet-into-wet washes with varying mixtures of Aureolin, Quinacridone Red and Permanent Magenta. The cherries on the left are warmer than those on the right. Leave highlights on each one, and keep in mind the lighting.

Add a few pink petals on top of the fabric. For the large shadow shape, mix large puddles of greens, blues and lavenders, and use a separate brush for each color. Starting on the right, add these colors in the same order, letting them mix to create a midtone value. While this is damp, use a tissue to dab out some of the color to soften the shadow. When the work is thoroughly dry, glaze a very light wash of the same colors over the entire shadow shape. Paint the same wash under the fruit and petals for their shadows.

Add more orange (Aureolin plus Quinacridone Red) to the persimmons to show form, and complete them with green stems.

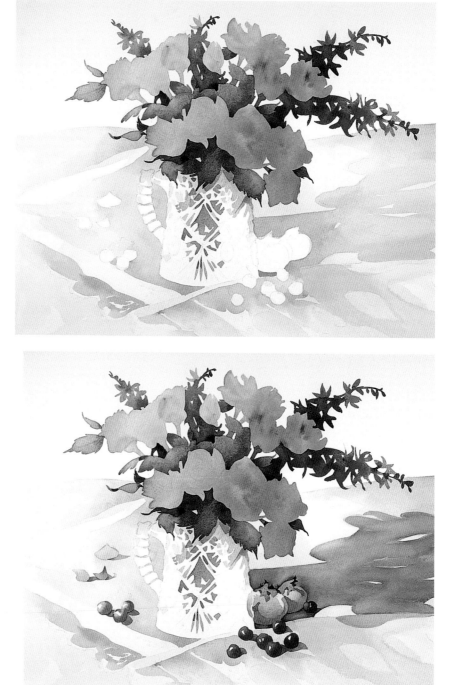

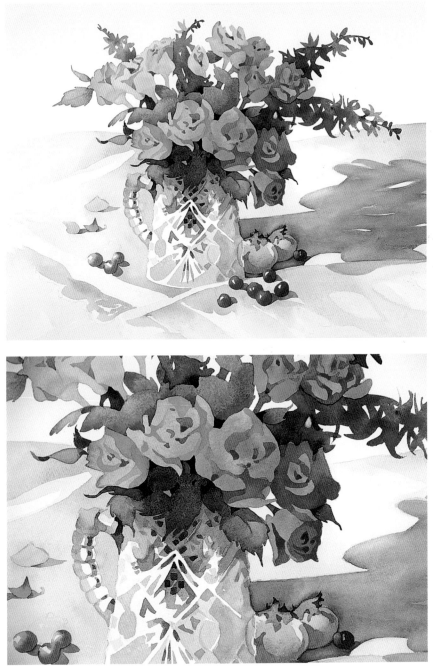

6 Continue the Roses and the Crystal Vase

When painting the roses, remember less is more. Work on the petal separations using warm orange (Aureolin plus Quinacridone Red) in the areas facing the light source. In the middle of the unit, add Quinacridone Red with Cadmium Scarlet to the orange to increase the value. Glaze the roses on the far right with Quinacridone Red and a little Cobalt Blue. When this dries, add a few dabs of color in the centers to finish them.

Start the left side of the vase with a little Aureolin, suggesting the pattern. Add Cobalt Blue to this yellow to paint the green tones, showing more pattern. Glaze the cool right side of the vase with Cobalt Blue and Quinacridone Red, darkening the values. Also add this color under the rose leaves at the top of the pitcher.

When that is dry, start to add more of the pattern using darker greens and blues. Do not overdecorate. You want the vase to be a secondary element in the composition. A few final darks under the rose leaves will complete the vase.

Vase Detail
See how many white spaces were left to describe the cut crystal. Notice in some cases there are areas without pattern, such as the right side by the persimmons. This lends a transparent quality to the vase.

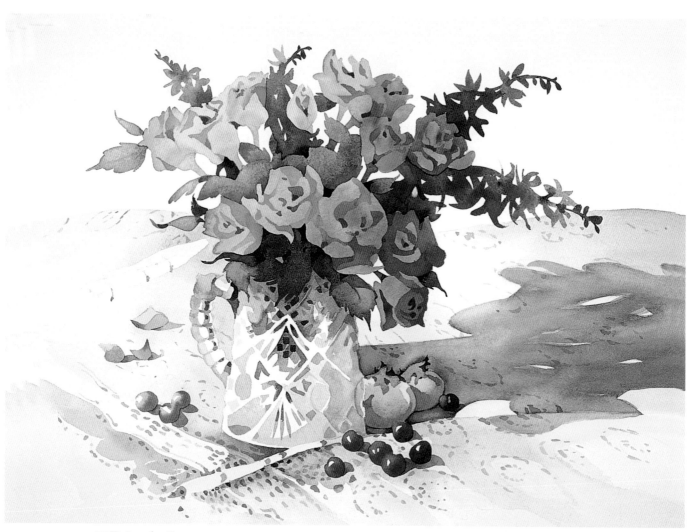

7 Paint the Lace

Even though the lace covers a large area, don't show the entire design; that would be distracting. You might want to draw the whole pattern to make sure it works, but you should paint only a small portion of it. After the drawing is completed, erase what you want to leave out. Paint this design with Cobalt Blue and Quinacridone Red. Notice that it darkens in the front folds and near the vase. Use a tissue to lighten the pattern as it fades out.

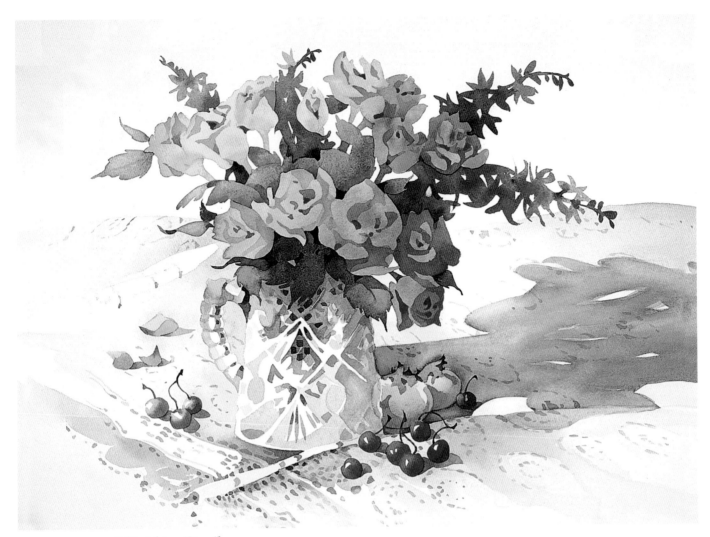

8 Finishing Details

All you have to add for details are the cherry stems, painted with green (Aureolin plus French Ultramarine) and Brown Madder. Instead of drawing them first, just dash them in where you want them. If you want deeper values, add a little more Cobalt Blue on the front fabric and to the right side of the vase. Add a touch of light orange (Aureolin and Quinacridone Red) to the fabric in front of the persimmons.

Notice the darkened value around the persimmons. This helps project them forward. Also notice the orange glow that is in back of them in the shadow shape. This reflected color helps tie the elements together.

FAVORITE TREASURES
17" × 23" (43cm × 58cm)

Make silk and dried flowers look real

In the winter I often set up a still life with silk and dried flowers. Some artists ask me how I can work from "colorless fakes." I equate it to an artist who paints animals from photos; you can't keep a real lion in your studio. It is up to you, the artist, to be creative. You can achieve this by your lighting choice, an exciting composition, great color and a well-set mood.

In the following demonstration the silk and dried flowers should be rich in color, with a springlike freshness. The goal is to make the finished painting look better than the reference photo.

MATERIALS

Paper
Stretched 140-lb. (300gsm) cold-press, 17" x 23" (43cm x 58cm)

Brushes
No. 5, 6, 7, 8, 10 and 12 rounds
Old oil bristle brush

Watercolors
Antwerp Blue
Aureolin
Brown Madder
Cadmium Scarlet
Cerulean Blue
Cobalt Blue
Hansa Yellow
New Gamboge
Permanent Magenta
Permanent Rose
Quinacridone Red

Other
HB pencil
Kneaded eraser
Tissues

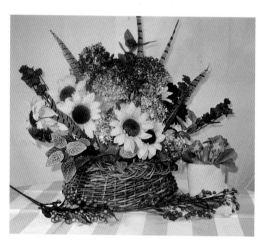

Reference Photo
This combination of dried and silk flowers is lighted from both sides. This creates rich values in shadow shapes around the sunflowers in the center of the unit, establishing a focal point.

The Plan
Important changes to the composition were made in this 9" x 11" (23cm x 28cm) color sketch. First, the sizes of all of the elements were reduced or enlarged depending on their importance to the overall design. The sunflowers should glow, so they are large and spread across the design. The other elements play a smaller role. Secondly, the color of the hydrangeas is a little richer in hue and value than the reference photo shows. This will offset the sunflowers.

I love painting feathers and their unique designs, so a few pheasant feathers were added to fill out the design. Small berries were also added for extra color notes. You will probably need to make more changes once you start painting. The sketch is simply a guideline for coloration and design.

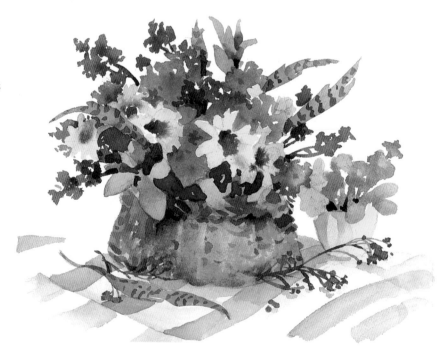

1 Make a Drawing

Carefully draw the flowers and basket. So you won't be tempted to paint every detail, don't draw all of the basket pattern. Just pencil enough to get the idea. The flowers are the stars of the show, so their size and placement should be clearly stated. I changed the shape of the small vase to repeat the round shapes of the basket and the flowers. Use a kneaded eraser to lighten the heavy pencil line before painting.

2 Lay In the Sunflowers

Mix large puddles of Aureolin, Hansa Yellow and New Gamboge. Using large, fully loaded brushes for each color, paint the sunflowers, letting the color mix on the paper. Starting on the left, use Aureolin; then as you move toward the center flowers, add Hansa Yellow to brighten them, as they will be in the focal point. Allow some of the yellow to flow down into the basket. Add New Gamboge wet into wet on some of the petals for a richer value. Paint the flower centers with New Gamboge and Brown Madder. For the small vase, apply a light wash of Hansa Yellow, with a touch of Cerulean Blue for the shadow on the left side.

3 Paint the Hydrangeas

Mix large puddles of Cobalt Blue, Permanent Rose, Cerulean Blue and Aureolin on your palette. Using a brush for each color, start painting with Cobalt Blue, adding a little red wet into wet. Move from one unit of hydrangea to the other, creating a large tonal mass. Use the brush tip to draw the outer edges of the flowers as you work this wash. To vary the wash, add little dabs of Cerulean Blue with Aureolin for a little green. It's important to leave small open spaces as a way to see through the flowers. Keep the value of this hydrangea mass midtone.

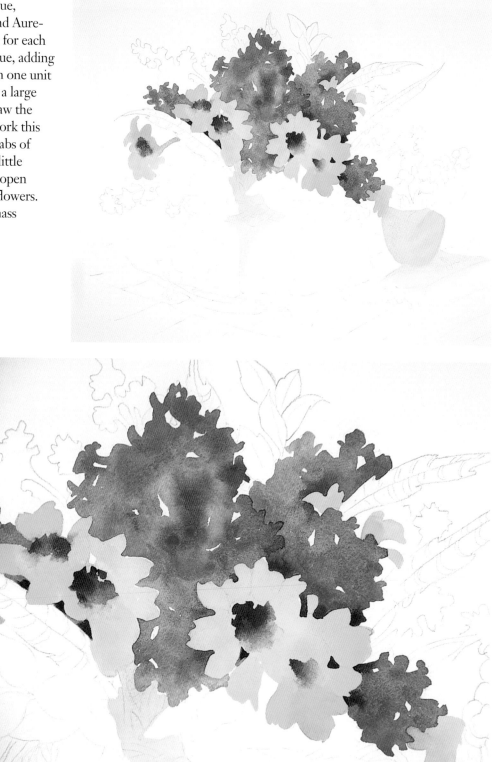

Detail

Here you can see how the sunflower petals were formed by painting the blue wash around them, finding their edges. The midtone value of the blue wash also helps to project the light sunflowers forward.

120

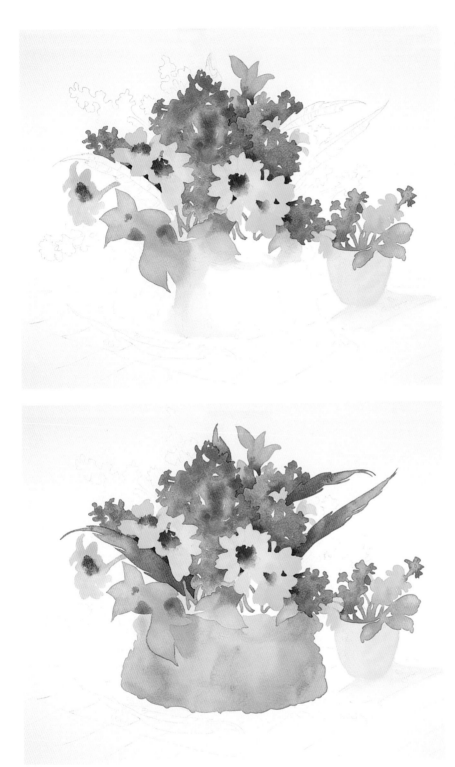

4 Add Orange Flowers and Leaves

Mix Aureolin and Quinacridone Red for a basic orange to paint the orange flowers wet into wet. Vary the percentage of each color to vary the wash. While the wash is still damp, add dabs of Hansa Yellow for an additional color change.

Mix puddles of Antwerp Blue and Hansa Yellow for a green wash, and paint this over all of the leaf shapes wet into wet, losing edges. While this is still damp, drop in dabs of Hansa Yellow and Cerulean Blue. Paint the stems inside the basket with the same yellow-green mix. Note how the green leaf wash was allowed to flow down into the basket. This helps to connect the subject matter.

5 Paint the Feathers and the Basket

To paint the feathers, combine transparent and opaque colors. For the first wash, mix Aureolin and Permanent Magenta to produce a clean, warm brown. Paint this over each entire feather. For color variance, add Hansa Yellow on the tips of the feathers, Cadmium Scarlet in the centers and Permanent Magenta near the bases. This offers a sense of light and shadow as well.

Flood the same yellow and red combination over the entire basket, wet into wet, to establish its shape. Add more Hansa Yellow in the center to suggest light and create a connector to the sunflowers. Let this wash dry devoid of any details, which can be painted later.

\mathcal{T}ip

An opaque, being a heavier pigment, will grab the paper and hold its position when applied. It will not bleed as fast as transparent colors will.

6 Paint the Additional Flowers and Fabric

Paint the small reddish purple flowers very quickly using a no. 6 round. Dash on Permanent Magenta, Permanent Rose and Brown Madder, wet into wet. If you take your time you might describe each little petal, but then these little flowers might lose their character. Add orange (Permanent Rose plus Brown Madder) to their stems.

When painting the fabric, don't think of the striped pattern right now. Paint only the shadow shapes first. Mix Cobalt Blue and Permanent Magenta to make a cool lavender. To this, add a small amount of Aureolin to produce a gray. Using a no. 12 round, flood this shadow wash under the folds to show their form. While this is still damp, add a little more yellow near the basket and small vase.

7 Develop a Few Details

Now that you've established the fabric shadows, paint the remaining feathers using the same colors as in step 5. The design on the feathers should be painted simply, not too dark or overstated. To accomplish this, use Antwerp Blue with a touch of Brown Madder and lightly paint the design. This greenish color glazed over the original color is more appealing than just adding brown or black.

The second wash over the basket is intended to increase the value as well as to show a little of the pattern. Mix Aureolin and Permanent Magenta to paint the negative shapes. Cool this wash with Brown Madder and Cobalt Blue to darken the values in shadow areas.

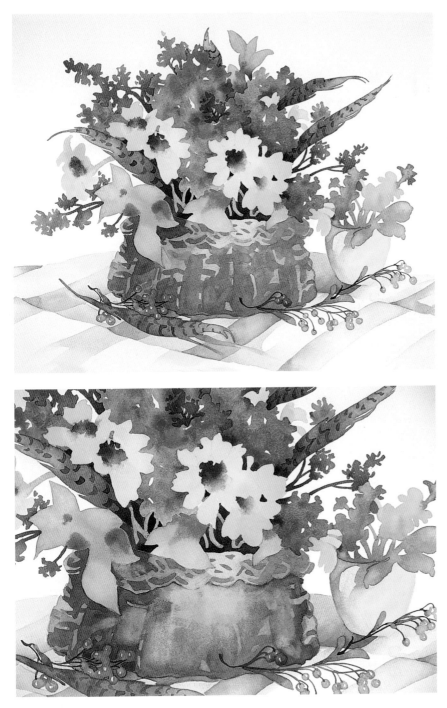

8 Connect the Elements

Give the berries a first coat of Aureolin and Quinacridone Red. Leave little whites for highlights. Keep the highlights small so they don't draw too much attention.

Paint the vase shadow using the same cool gray wash that was used for the fabric, again connecting the elements.

Paint the berry leaves with a cool green mix of Aureolin and Cobalt Blue, plus an additional touch of pure Aureolin to finish them.

Now that the fabric folds are in place, you can paint the stripes that go over or under, as the fabric shows. Paint them with the same colors as the shadows (Cobalt Blue, Permanent Magenta and Aureolin, but a little darker or lighter as they cross the fabric.

When the fabric has dried, paint the berry stems using Brown Madder and Cadmium Scarlet.

Mix a good dark with Permanent Magenta and Brown Madder to paint the inside of the basket seen around the stems. This provides the weight and value needed to set the focal point.

9 Make a Few Changes to the Basket

Using Antwerp Blue and Brown Madder, paint the dark shadow shapes on the basket and let them dry. Then, use a damp tissue to lift out some of this color, to soften edges and to lose some of the pattern. When this is thoroughly dry, glaze Aureolin over the front of the basket. These additions give the basket more weight and solidity before the final details are added.

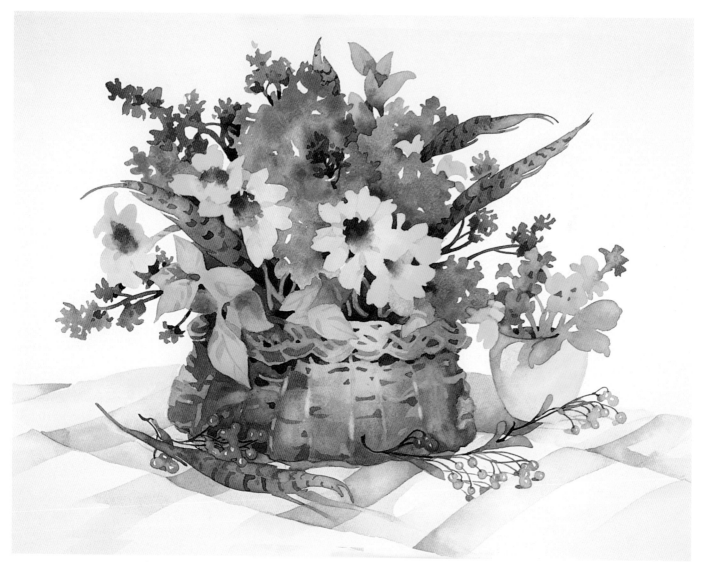

10 Check Values and Details

To maintain the freshness of the painting, make some additions. Glaze a little orange (Aureolin plus Quinacridone Red) on the stems in the basket to push them back. Mix a nice grayed purple (Quinacridone Red, Cobalt Blue and Aureolin) to add to the small shadow shapes under the berries. Add a little more value to the reddish purple flowers using the same colors, and add Brown Madder to their stems. Paint just a few dabs of darker orange (Cadmium Scarlet) on the little flowers in the small vase and for the little dark area inside the vase. The sunflowers are basically finished; however, add just a few petal separations with Antwerp Blue and Hansa Yellow. Add a touch of Antwerp Blue to the petal tips to reflect the green leaves. Finally, add a few key darks to the basket and just enough negative shapes to describe the basket without going into painstaking detail.

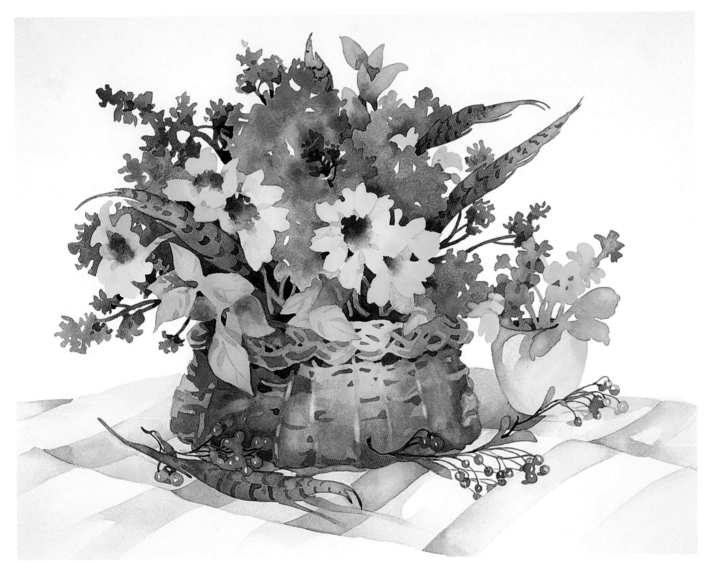

11 Make a Small but Important Addition

In viewing my painting with a mat over it, I realized that I had neglected to add the small piece of blue hydrangea on the left side of the design, beside the sunflower furthest left. I could have said, "Forget it," but I found this detail necessary in order to stretch out the design. Place your thumb over this area. See how the basket and flowers line up almost perfectly in the shape of a vertical cylinder. Now look at the addition of the extra blue flower. It saves the day!

My Garden Collection
17" × 23" (43cm × 58cm)

Index

The best in watercolor instruction and inspiration is from **North Light Books!**

Here's all the instruction you need to create beautiful, luminous paintings by layering with watercolor. **Linda Stevens Moyer** provides straightforward techniques, step-by-step mini-demos and must-have advice on color theory and the basics of painting light and texture—the individual parts that make up the "language of light."

ISBN 1-58180-189-0, HARDCOVER, 128 PAGES, #31961-K

Nature paintings are most compelling when juxtaposing carefully textured birds and flowers with soft, evocative backgrounds. Painting such realistic, atmospheric watercolors is easy when artist **Susan D. Bourdet** takes you under her wing. She'll introduce you to the basics of nature painting, then illuminate the finer points from start to finish, providing invaluable advice and mini-demos throughout.

ISBN 1-58180-458-X, PAPERBACK, 144 PAGES, #32710-K

Artist and teacher **Jan Kunz** reveals her secrets for painting luminous watercolor compositions inspired by photographs. Complete with more than 200 full-color pictures and eight step-by-step demonstrations, you will learn a variety of techniques as you practice painting compositions that include people, flowers, animals, scenery and more.

ISBN 1-58180-431-8, PAPERBACK, 128 PAGES, #32599-K

Paint splendid watercolor still lifes that capture the look, feel and spirit of each season. With 27 step-by-step demonstrations, **Donald Clegg** shows you how to paint the details of sunflowers, pansies, cherries, dried leaves and other beautiful items as well as create finished paintings. You'll also find sidebars devoted to gardening and cooking to help capture the feel of your favorite season in watercolor...and in life!

ISBN 1-58180-285-4, HARDCOVER, 144 PAGES, #32160-K

These books and other fine art titles from North Light Books are available at your local art & craft retailer, bookstore, online supplier or by calling 1-800-448-0915 in North America or 0870 2200220 in the UK.